American
STONEWARE

A WALLACE-HOMESTEAD PRICE GUIDE

American STONEWARE

DON & CAROL RAYCRAFT

Wallace-Homestead Book Company
Radnor, Pennsylvania

Acknowledgments

Opal Pickens
Dr. Alex Hood
Bruce and Vicki Waasdorp
Steve Rhodes
JMC Productions
Gerald and Lorraine Coffman
Brenda Humphrey
Al Behr

Photography

Bruce and Vicki Waasdorp
Don and Carol Raycraft

Published in Radnor, Pennsylvania 19089, by Wallace-Homestead,
a division of Chilton Book Company

Designed by Anthony Jacobson
Cover photo by Carol Raycraft
Manufactured in the United States of America

Library of Congress Cataloging-in-Publication Data
Raycraft, Don.
 American stoneware : a Wallace-Homestead price guide / by Don &
Carol Raycraft.
 p. cm.
 Includes bibliographical references (p. 154).
 ISBN 0-87069-714-5
 1. Stoneware—Collectors and collecting—United States—Catalogs.
I. Raycraft, Carol. II. Title.
NK4634.R387 1995
738.3'0973'075—dc20 95-12045
 CIP

1 2 3 4 5 6 7 8 9 0 4 3 2 1 0 9 8 7 6 5

Contents

Introduction

Decorated American stoneware is primarily a product of the nineteenth century. In the late 1700s there were a few stoneware potteries operating in urban areas (New York, Boston) and almost none in rural settings. The smaller rural potteries in the late eighteenth century produced redware rather than stoneware crocks and jugs. Redware was turned out in huge quantities from the mid-1600s until almost 1900 in some rural areas.

In most areas of Pennsylvania, the clays used in the manufacture of redware pottery could be found easily with a shovel. The redware was fragile, difficult to transport any distance over rough roads, and extremely porous. It was also sealed with a colorless glaze that contained a great deal of lead.

Redware potters rarely signed or marked their pieces with a stamp, which makes it difficult to date a piece of redware or identify where it was made.

The number of stoneware potteries in the eastern United States gradually increased from a few to hundreds by the middle of the nineteenth century. Because it was fired in kilns to more than 2100 degrees Fahrenheit, stoneware was much more durable than redware, and therefore in demand with nineteenth-century consumers. It was also easily cleaned and able to

withstand extreme heat and cold with few problems. Unlike the lead glaze on redware that slowly and silently killed some unsuspecting consumers over time, stoneware potters used a salt glaze that presented no health-related problems.

Stoneware products were predominantly used for household storage of food and drink until the turn of this century, when inexpensive mass-produced glass jars and bottles and home refrigeration made stoneware obsolete and forced the potteries to close.

Stoneware Chronology

1400s Saltglazing of stoneware in Europe is becoming commonplace.

1600s Salt-glazed stoneware jugs, crocks, dishes, and mugs are being produced in England.

1730s John William Crolius and John Remmey are making stoneware in New York City.

1730s Redware potters in Pennsylvania have established numerous kilns.

1790 William Seaver of Taunton, Massachusetts is an early New England stoneware potter.

1793 John Norton opens a pottery in Bennington, Vermont that will remain in operation under a variety of owners until 1894.

1825 The Erie Canal is opened and connects the Hudson River to the Great Lakes and makes it simpler and less expensive to transport clay and finished stoneware to new markets.

1870– early 1880s Cowden and Wilcox are making stoneware in the Harrisburg, Pennsylvania vicinity.

1877 Red Wing Stoneware Company of Red Wing, Minnesota, begins to mass-produce a variety of stoneware products. The pottery continues for almost 90 years.

late 1870s Home canning, oak ice boxes, inexpensive glass jars, and bottles take a major toll on stoneware manufacturers and force even more mass production and molding of stoneware.

1880s Stoneware potteries gradually begin to consolidate or close their doors due to innovations with which they cannot compete.

1900 The annual production of salt-glazed stoneware has diminished to almost nothing.

PART I

Collector's Guide to American Stoneware

CHAPTER ONE
Nineteenth-Century Stoneware

Unlike art pottery from the first half of the twentieth century that was designed to be collected and displayed on an oak table from Sears or given to a favored aunt or uncle as an anniversary gift, decorated American stoneware was totally utilitarian. It was produced to hold water or spirits in jugs ranging up to six gallons or to store garden and orchard produce in large crocks.

Condition: What to Look For

Almost all pieces of stoneware that potential buyers have an opportunity to inspect in private collections, shops, or at auctions are flawed to varying degrees. It is almost a given that every piece of stoneware is less than perfect. The flaws are to be expected because in addition to being a functional product, stoneware also was subject to numerous variables that were impossible to control once the piece was placed in the kiln for the firing process. Among the many flaws may be cracks, "fried" cobalt, flaking glaze, chips, burns or brown spots, or "salt tears."

There are several varieties of cracks that can affect the desirability and value of a piece of stoneware. A harmless crack in the clay that occurred while a piece was drying prior to being placed in the kiln is called a "dry-

ing line." These were usually covered by the salt-glazing process in the kiln and are not considered serious. A "hairline crack" is a second type which, by definition, does not extend through the body of the piece of stoneware. It is a thin surface crack, which may, however, deepen over time. A crack which extends entirely through the surface usually requires professional restoration or repair.

If the kiln became too hot during the firing process and there was too much water in the cobalt slip (a mixture of cobalt oxide and liquid clay), the cobalt decoration often bubbled or burned away. Since most collectors are primarily interested in decoration, a jug with a cobalt bird that has bubbled over or fried loses value. Other flaws in the decoration process sometimes occurred when the heat generated in the kiln turned the normally blue cobalt black or caused the decoration to run or blur.

Collectors are especially concerned about flaking glaze because it cannot be controlled. In a sense, flaking is like a cancer that alternates between periods of aggressiveness and periods of remission.

Stoneware was inexpensive and readily available to most Americans after 1840. It was used daily and, consequently, many pieces were chipped on the base, pouring spout, or rim. Most pieces of decorated stoneware that have great value should have chipped areas professionally restored. Chipped canning jars priced at $175 normally are enjoyed without the necessity of professional repairs.

If a piece of stoneware was too close to the fire in the kiln, a brown spot or kiln burn usually resulted. It is not uncommon to find the glaze burned off down to the surface on a section of a crock or jug.

A salt tear gives the impression that someone expectorated on the side of the piece. Salt tears are greenish bubbles created when a kiln with an overabundance of salt cooled off too quickly.

Hundreds of potteries, from Maine to the Mississippi and beyond, made and decorated utilitarian stoneware during the nineteenth century. Relatively few pieces have survived without some chips, cracks, nicks, pings, frys, and flaking because the pieces were made to be used. They were available in quantity, inexpensive, and difficult or impossible to repair if cracked or dropped.

Collectors should be concerned with much more than the amount of "blue" a piece may have.

Products of the Stoneware Potteries

Utilitarian stoneware was popular because it could be used for storage, pickling, and preserving food, and it added no taste or odor to the contents. It was also inexpensive, easily cleaned, and readily available in most areas. Most stoneware companies produced a wide range of products. Among the less frequently found items are foot warmers, bedpans, spittoons, poultry fountains, inkwells, flowerpots, pitcher and bowl sets, flasks, milk pans, and mugs. Some notes on the more common items, such as jugs, bottles, and crocks appear below.

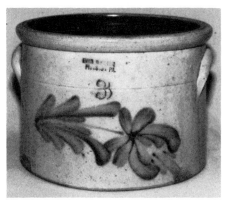

Three-gallon crock with brushed cobalt flower and impressed capacity and maker's mark from Pittston, Pennsylvania.

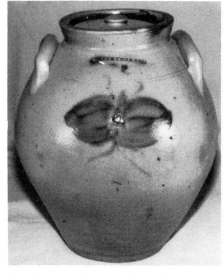

Ovoid two-gallon jar from Bennington, Vermont, signed "Norton & Son."

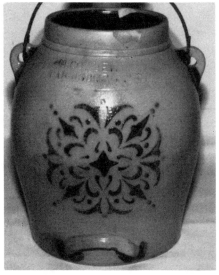

Stenciled decoration on a Cowden butter pail signed "F. H. Cowden, Harrisburg."

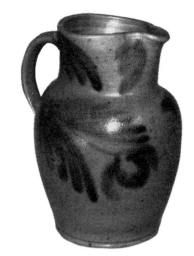

Unmarked milk pitcher with brushed decoration.

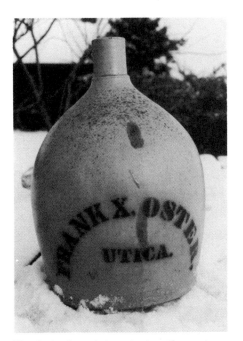

Jugs

Liquids were stored in jugs which were commonly made in sizes from ½ gallon to 6 gallons. Six-gallon examples usually had double handles. Jugs with pouring spouts were used for molasses or syrup.

Bottles

Stoneware bottles, which were rarely decorated with anything other than a splash of cobalt blue, were made for breweries, taverns, and stores. Few were sold to individuals. Originally bottles were sealed with a cork, but after 1892 a wire-lever lid was added. After 1855 most bottles were molded or cast rather than thrown on a potter's wheel. Few bottles carry a maker's mark, but many have a merchant's name impressed into the side or neck.

Vendor's jug, late nineteenth century, Utica, New York.

Crocks

Crocks were used for preserving, storing, and pickling. Common sizes range from 1 gallon to 10 gallons, but 50-gallon crocks were occasionally made. After 1860 many crocks were made with stoneware lids.

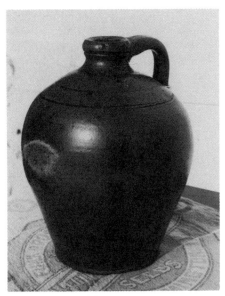

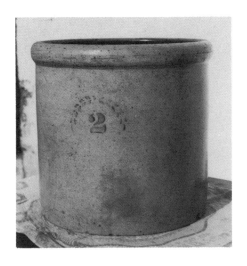

One-gallon stoneware jug, c. 1840, New England, unmarked.

Two-gallon midwestern crock, c. 1900, stenciled capacity mark.

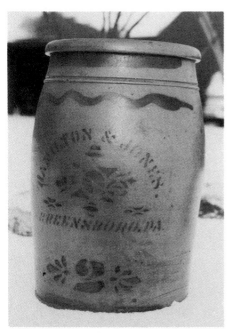

Batter Jugs (Pails)

A batter jug has a wide mouth and a pouring spout. Tin lids and caps were made for the mouth and spout. Few batter jugs have survived with their original lid or cap. Batter jugs usually were available in sizes from 3 to 6 quarts, were often unmarked, and were not heavily decorated. A wire bail handle with a maple grip was used to lift the batter jug.

Pitchers

Pitchers, in sizes ranging up to 2 gallons in capacity, were rarely signed (marked) or heavily decorated. Pitchers were used for storing and serving water, cream, milk, or syrup. Early examples have bulbous bodies and late examples have cylindrical sides. After 1875, Albany slip (brown) was used by many potteries to decorate stoneware pitchers.

Two-gallon crock, 1880s, Hamilton & Jones, Greensboro, Pennsylvania, stenciled and brushed decoration.

Jars

Jars range in size from 1 quart to 6 gallons and were used for preserving and storing foods. In 1892 a wire-lever lid was patented. Prior to that date, the jars were sealed with wax and had tin or wooden lids. Jars from the 1890s also had zinc screw caps of the kind later used on glass preserve jars.

Churns

Ovoid or cylindrical churns usually were sold with wooden lids and wooden dashers, although stoneware lids also were available. Churns were commonly made in sizes ranging from 2 to 12 gallons. Many churns are found without a maker's mark.

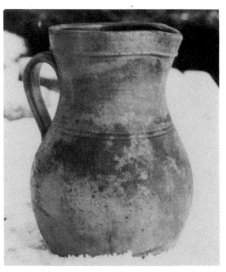

Pitcher, mid nineteenth century, Whites, Utica, New York.

CHAPTER TWO

How Stoneware Was Created and Decorated

The Manufacturing Process

It was a common practice for potteries to purchase their clay from an outside supplier. To stretch their stock, many potteries mixed inferior local clays with the more expensive and higher-quality imported variety. The mix of local and imported clay is a major factor in the range of colors of surviving nineteenth-century stoneware.

After the clay was delivered, it was mixed with water and then carefully filtered to remove stones or clumps of hard clay. For the sake of consistency, it was also necessary to knead or work the excess water out of the clay before it could be formed into jugs or crocks on the potter's wheel.

Potters used their hands to shape pre-measured or weighed balls of clay that had been placed on the wheel. The speed of the wheel was regulated by the potter's foot, and a strand of wire was used to separate or cut the finished piece from the wheel. Handles were added once the desired shape was achieved.

The stoneware was allowed to dry for 24 to 72 hours in an enclosed drying area or outside in the sun on shelves. The pre-fired ware

is properly designated "greenware." The greenware was coated on its interior with a chocolate-colored mixture of water and clay called Albany slip.

Cobalt slip was then brushed or slip-trailed onto the surface of the piece. The decoration could range from a hastily executed capacity mark to an elaborate flower or pastoral scene.

Stoneware to be fired was carefully stacked in a brick-lined kiln that was heated slowly with wood until the temperature climbed to about 2300° Fahrenheit. When the interior of the kiln approached the highest temperature of the firing process, salt was thrown or shoveled in. The salt vaporized and covered the exposed surface of each piece with a glaze. The temperature in the kiln was maintained for another 36–72 hours and then allowed to gradually drop.

The three key elements in the production of nineteenth-century stoneware were:

a. The actual forming of the piece on the potter's wheel.
b. The careful stacking of the greenware in the kiln.
c. The consistency of the temperature in the kiln during the firing process.

The Stoneware Decorator's Art

As the nineteenth century wound down and the competition between stoneware potteries reached its pinnacle, few pieces were heavily decorated. Each pottery attempted to produce their wares as economically as possible, and the cobalt decoration was an extra step that created additional costs. The advent of mass-produced molded

Slip-trailed floral spray.

The J. and E. Norton Pottery of Bennington, Vermont (1850–1859) sometimes offered a detailed pheasant on a tree stump.

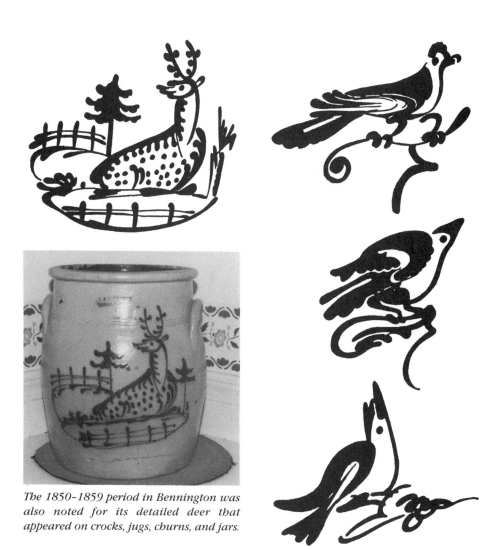

The 1850-1859 period in Bennington was also noted for its detailed deer that appeared on crocks, jugs, churns, and jars.

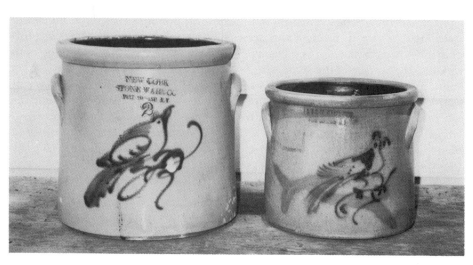

stoneware and stenciled decoration eventually forced the closure of most businesses that used potters to throw each piece individually on a wheel. It was impossible to compete with a machine.

The floral spray was a popular cobalt decoration in the 1870s and early 1880s. Like the wide variety of birds that appear on stoneware, the floral sprays include few flowers that can be specifically identified. The majority of the decorators at the eastern potteries were women who borrowed bits and pieces of images from a variety of birds to create their slip-trailed or brushed images on salt-glazed stoneware. Many potteries, such as Fort Edward, New York, were known for particular birds.

Decorating Techniques

Four major techniques were used to decorate nineteenth-century American stoneware. These included incising, brushing, slip-cupping or slip-trailing, and stenciling.

Incising

Incising was a process popular among potters from the late eighteenth century through the first quarter of the nineteenth century. The decorator used a metal tool or a sharp piece of wire to scratch a flower, bird, ship, or capacity mark into the surface of the stoneware. Incised stoneware is difficult to find as relatively few pieces have survived, and elaborately decorated pieces command serious dollars. Even though only a small minority of the nation's stoneware collectors actively seek incised examples, they typically are foced to pay much higher prices than

individuals who seek out the best in brush or slip-cup decorated jugs, crocks, and churns.

Slip-Cupping or Trailing

Slip-cupping or slip-trailing involved pouring a thin line of cobalt slip from a "cup" in a process similar to cake decorating. The slip-cupping left a raised line of cobalt decoration on the surface of the stoneware. This technique was used from the late 1830s through the 1880s, with some of the best examples being produced in the 1850s and 1860s.

Brushing

Brushed decoration was achieved by dipping a brush in cobalt slip and painting the surface of the stoneware. Designs ranged from simple swirls and capacity marks to scenes of circus acrobats, battleships, or exotic animals like zebras and elephants. The brush was the most common tool used to decorate stoneware between 1850 and the 1880s.

Stenciling

The decade of the 1880s saw a gradual change at most potteries, eventually leading to the mechanization of stoneware production and the demise of local potteries that made individual pieces on a potter's wheel. It had become too expensive to employ both a potter to produce a piece and a decorator to hastily brush on a splash of cobalt. As a result, stencil decorations became the norm, replacing the brush or slip-cup variety. Stencils were used from the early 1880s to the 1920s, by which time most stoneware potteries in the United States had gone out of business.

14

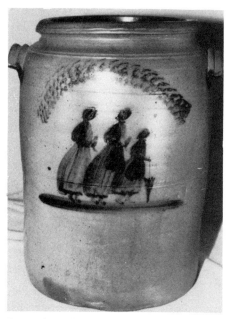

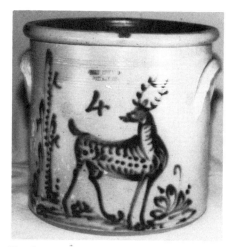

The four-gallon crock signed "Fort Edward Pottery Co." has a slip-trailed scene that includes a deer, stump, and ground cover.

Examples of American stoneware decorated with people are extremely rare.

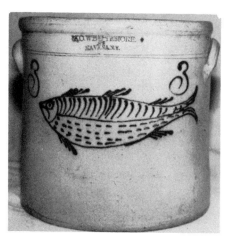

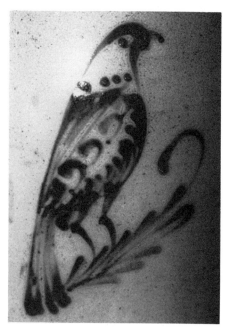

The slip-trailed fish is signed "A. O. Whitmore, Havana, N.Y."

Most birds that have been slip-trailed or brushed on stoneware combine characteristics of robins, bluebirds, chickens, hawks, and eagles. Rarely did a bird resemble one that actually appeared in the wild or in the apple tree in the backyard.

STONEWARE RARITY CHART

Description	Common	Uncommon	Rare	Extremely Rare
Elaborate bird on a branch with detail		✗		
Hastily brushed "3"	✗			
"3" surrounded by an ornate cobalt wreath		✗		
Two American flags in a holder				✗
"Man in the moon"				✗
Lion, zebra, or elephant with detail				✗
Stag, trees, ground cover, fence			✗	
House with trees, ground cover, fence, architectural detail			✗	
Simple cobalt tree with ground cover			✗	
Detailed double birds on a branch			✗	
Cobalt bird with minimal detail		✗		
Hastily executed flower	✗			
Elaborate and detailed cobalt flower(s)		✗		
Simple swirl or geometric lines	✗			
Undecorated	✗			

Common=Can often be found at farm sales, flea markets, antiques malls, and house or tag sales.

Uncommon=Can be found at some antiques shows and shops but usually will require some semi-serious effort to locate.

Rare=Can be found occasionally at "important" antiques shows and exceptional shops that specialize in American country antiques for serious collectors; usually takes deep pockets and a significant investment in time to find.

Extremely Rare=Handled by less than a dozen dealers in the United States. Examples seldom reach the general market and are usually sold within a small network of advanced dealers and collectors.

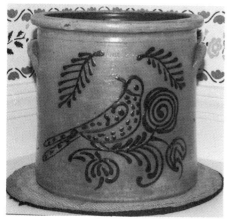

Elaborate bird on a branch with detail.

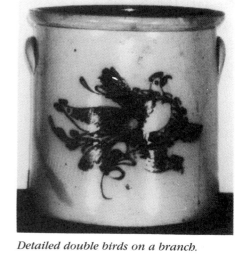

Detailed double birds on a branch.

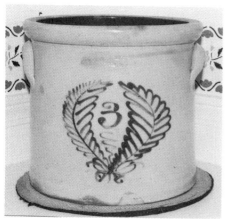

"3" surrounded by an ornate cobalt wreath.

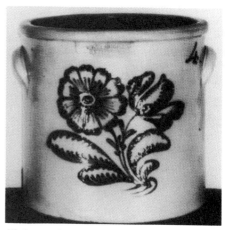

Elaborately executed flower with detail.

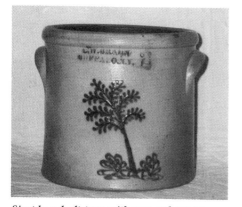

Simple cobalt tree with ground cover.

CHAPTER THREE

Collecting Decorated Stoneware

Collectors of American stoneware evaluate a piece on the basis of decoration, condition, form, and maker's mark. Since most stoneware decorators were paid on the basis of how many pieces they handled during the course of a workday, few workers were inclined to spend much time on an individual piece.

After 1870, the competition among potteries became so intense that every possible corner was cut to keep the price of production down, and, as a result, the quality of decoration on most pieces declined. On rare occasions an elaborately decorated piece was created as a special order for a gift or award or was made as an "end-of-the-day" piece by an employee of the pottery.

Much of the value of a piece of stoneware is determined by its decoration. Pieces with birds, people, scenes, or animals are difficult to find today. Generally, the more elaborate or intricate the decoration, the more expensive the piece will be. The most commonly found decorated examples carry hastily executed lines, swirls, or simple flowers.

Condition

A chipped, cracked, or flaking piece of stoneware with simple decorations will not appeal to a serious collector. On the other hand, buyers are more willing to overlook damage to a piece dated 1814 that also has a battleship incised into its side. Pieces with high-quality decorations are so difficult to obtain that flaws have become more acceptable and are even expected.

Form

During the first 40 years of the nineteenth century, stoneware was pear-shaped or ovoid, i.e., broad-shouldered and tapered to a narrow base. Ovoid stoneware was time-consuming to make and difficult to transport, and it gradually gave way to shapes that took less time and skill to produce. Collectors are constantly competing for an ever-diminishing supply of ovoid examples.

Maker's Marks

The vast majority of collectors are much more concerned with the decoration, condition, and form of a piece than with where the piece was made. There were hundreds of stoneware potteries in nineteenth-century America; most went out of business due to fires, explosions, or bankruptcies.

The pottery in Bennington, Vermont, went through at least 12 distinct combinations of owners and marks during the nineteenth century. The longest period of continuous ownership was from 1861–1881 when it was operated by E. and L. P. Norton. Serious collectors who seek specific marks are especially interested in pre-1840 makers and stoneware that carries a one- or two-year mark. The E. and L. P. Norton mark was a 20-year mark. It is important to keep in mind that not every piece of stoneware manufactured in the nineteenth century was marked.

Brief History

Stoneware is largely a product of the nineteenth century, but potteries were in existence in New York City as early as the 1730s (e.g., Crolius, Remmey). New York State became a center for many potteries because of the availability of clay and water transportation. The towns of Utica, Lyons, Binghamton, Geddes, Buffalo, Albany, Poughkeepsie, Troy, and Fort Edward all had successful stoneware potteries in the mid-1800s. Much of the stoneware made between 1880 to 1920 was cast or molded rather than hand-thrown. Minnesota, Illinois, and Ohio replaced New York and Pennsylvania as

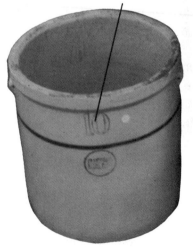

Stenciled capacity mark

Ten-gallon molded crock, twentieth century, Bristol glaze, cylindrical sides.

20

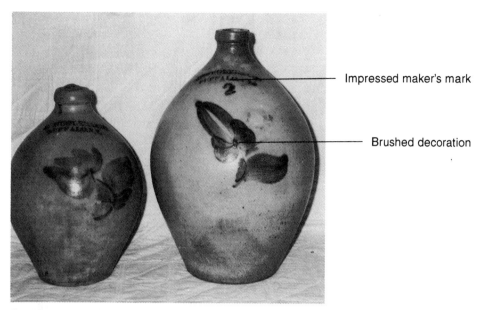

Impressed maker's mark

Brushed decoration

Ovoid jugs, c. 1840.

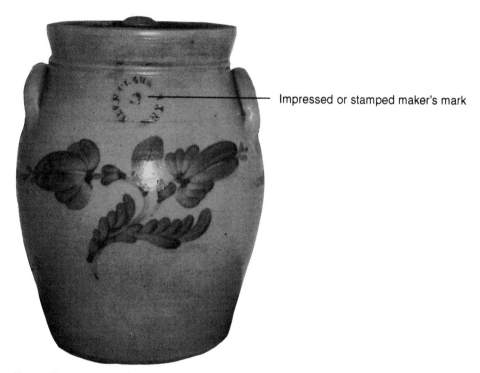

Impressed or stamped maker's mark

Two-gallon covered pot or jar. Salt-glazed, semi-ovoid form with applied ears or handles and brushed decoration.

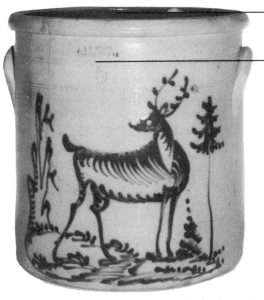

Albany slip interior

Impressed maker's mark and capacity mark

Five-gallon crock with intricate cobalt slip-trailed stag, trees, and ground cover. Salt glazed with cylindrical sides.

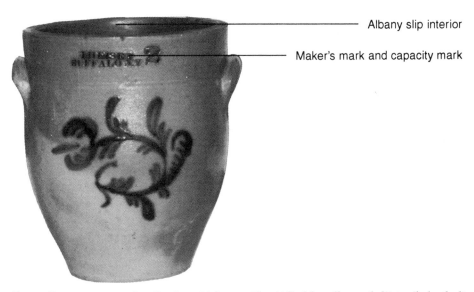

Albany slip interior

Maker's mark and capacity mark

Two-gallon open pot or jar. Semi-ovoid form with applied handles and slip-trailed cobalt decoration.

the major states for the production of stoneware. After 1920, few potteries remained due to the common use of household refrigeration, mass-pro-duced bottles and glass jars. The enact-ment of Prohibition outlawing the sale of alcoholic beverages destroyed the market for stoneware bottles.

Restoration and Repairs

As the demand for American decorated stoneware continues to increase, varying degrees of damage or repair have become more acceptable. Advertisements describing pieces as "restored," "repaired," or "sealed" can be found in antiques publications, and some collectors are confused as to what these terms mean. Stoneware dealer Al Behr defined repair as "an operation that enhances a piece structurally, and can include staples, wire, glue, and filling material."

He defines restoration as "the repair process plus a cosmetic addition designed to mask the repair, or at least make it much less obvious. The cosmetic process is paint of some kind, usually by an air gun. The paints used are usually very tough and are permanent, if cared for properly. The restorer tries to blend his work with the surrounding color, or sometimes creates an intentional blemish on the area which might look like a kiln burn."

Sealing is a gluing process, usually using a very high-strength, insoluble, temperature-resistant glue, which is applied in a crack, sometimes from the inside, and only after the line or crack is properly aligned by use of wood frames or vises. The piece is then closed, and pressure is applied until thoroughly dried. A properly sealed piece will not crack or break any further, nor will it break at the repaired point even if dropped.

Behr concludes, "If a piece of stoneware has been restored, repaired, or sealed, the seller has the responsibility to inform the potential buyer of the alterations. The buyer of a piece of stoneware should secure a receipt with a full description of the piece and any change it has undergone."

Evaluating Selected Pieces

It can take a lifetime of serious study to gain an understanding of the nuances of American furniture or glass. Collectors of American stoneware have a less arduous path to traverse and can actually glimpse a faint glow at the end of the tunnel after a period of concentrated observation.

There are some basic pieces of information that must be digested to intelligently and realistically evaluate American stoneware. Hopefully, the information that follows will be of assistance.

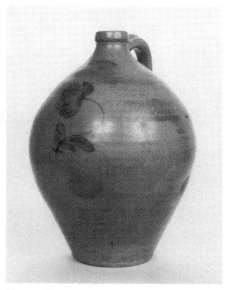

Two-gallon jug with brushed flower and leaf, ovoid, c. 1830–1840, made in Troy, New York, marked "I. Seymour, Troy Factory."

AVAILABILITY: Examples of American stoneware from this period in original condition without chips, cracks, or other distortions are uncommon. Pieces of this quality are still available

in limited quantities from dealers who specialize in early decorated stoneware.

INVESTMENT POTENTIAL: A piece of this quality will continue to increase in value over time. In the short run, the increases will be gradual but consistent.

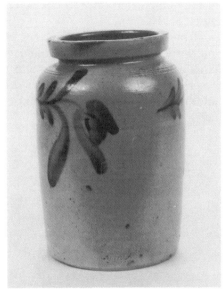

Stoneware jar, mid nineteenth century, brushed tulip and leaf decoration, pristine condition, unmarked.

AVAILABILITY: A collector should be able to find decorated stoneware jars at Americana shows and from stoneware dealers. The demand for decorated examples is going to outdistance the supply in the near future.

INVESTMENT POTENTIAL: Decorated stoneware jars in good condition make a strong investment. Cracks and chips have a dramatic effect on their value. An example with a cobalt bird or even a maker's mark would make an even better investment.

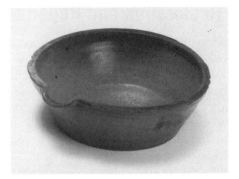

Milk pan, late nineteenth century, hand-thrown, New York State or Pennsylvania in origin, unmarked and undecorated.

AVAILABILITY: Milk pans are not commonly found. Heavily decorated milk pans are rare. Marked and decorated milk pans are especially difficult to locate.

INVESTMENT POTENTIAL: An undecorated/unmarked piece of stoneware typically does not have a great deal going for it. A piece like this example would be of interest to someone gathering a representative sampling of stoneware products. The investment potential would be limited.

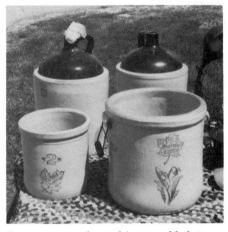

Stoneware crocks and jugs, molded, twentieth century, Bristol glaze, stenciled decoration.

AVAILABILITY: Commonly available at shops, shows, antiques malls, farm sales, and local auctions.

INVESTMENT POTENTIAL: Examples in perfect condition have minimal potential for growth in value at this time. The exception would be a locally produced piece that is in short supply and may have considerable interest to a specific collector.

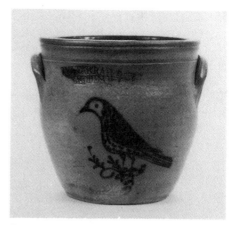

Stoneware crock, 1870s, W. H. Farrar and Company, Geddes, New York, slip-trailed bird on a branch, impressed maker's mark.

AVAILABILITY: A piece of this type would probably be found in the inventory of a major stoneware dealer or at an important stoneware auction.

INVESTMENT POTENTIAL: Quality pieces of decorated stoneware are sought out by collectors of folk art and also serious investors in stoneware. This piece has significant long-term potential because of its decoration and condition.

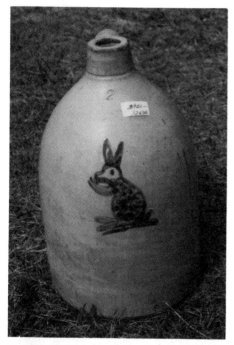

Two-gallon stoneware jug, 1880s, brushed rabbit decoration, cylindrical sides, exceptional condition, impressed capacity mark.

AVAILABILITY: Animals on any piece of stoneware from the nineteenth century are rare.

INVESTMENT POTENTIAL: This is another piece that would be of interest to both the stoneware and folk collector, which would probably enhance the price.

Ten-gallon crocks, early 1900s, molded, Red Wing, Minnesota, Bristol glaze, stenciled decoration.

AVAILABILITY: Made in such huge quantities that many have survived.

INVESTMENT POTENTIAL: There are a significant number of Red Wing collectors who compete for unusual pieces of stoneware. Eventually anything in exceptional condition with a Red Wing mark will increase in value. In the short term, the increase in value will be negligible.

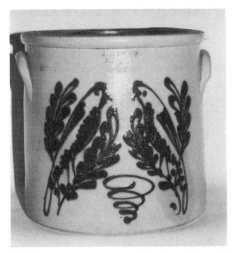

Four-gallon crock, c. 1880, Fort Edward, New York, slip-trailed double birds on branches in deep cobalt blue.

AVAILABILITY: A single bird on a branch that takes up the majority of the front of a four-gallon crock would be uncommon. This example is truly rare.

INVESTMENT POTENTIAL: The value of this piece will increase consistently and substantially over the next several years. It is another example of a piece that would be of interest to both folk art and stoneware collectors.

Ten-gallon stoneware crock, molded, Bristol glaze, stenciled capacity mark.

AVAILABILITY: Commonly found in any environment in which antiques and collectibles are offered for sale.

INVESTMENT POTENTIAL: Minimal.

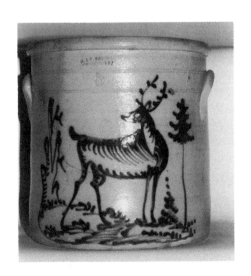

Five-gallon crock, J. & E. Norton, Bennington, Vermont, detailed ground cover, trees, and stag in deep cobalt blue.

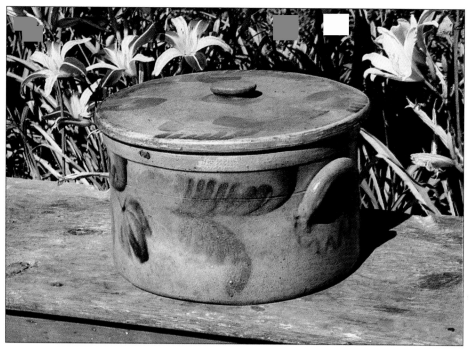

Cake or butter crock, decorated, unmarked. $450–$550

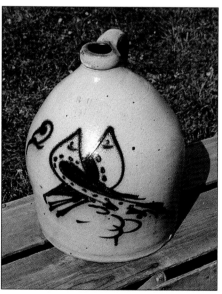

Stoneware jug, double cobalt birds.
$850–$1,250

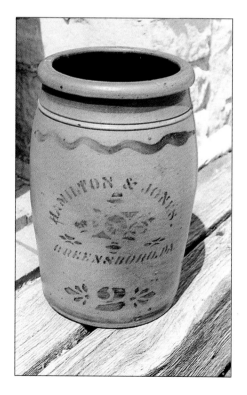

Two-gallon jar, Pennsylvania, stenciled
decoration. $325–$375

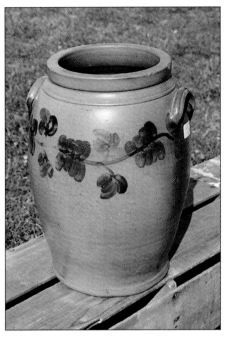

Stoneware jar, cobalt decorated.
$450–$550

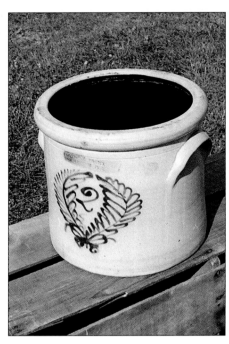

Two-gallon crock, New York state.
$375–$450

Pitcher, sponge decorated, molded.
$325–$375

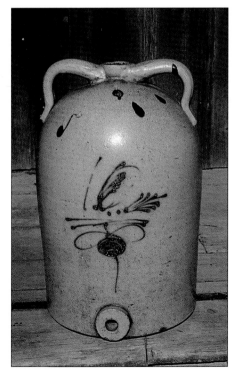

Cooler, midwestern. $350–$375

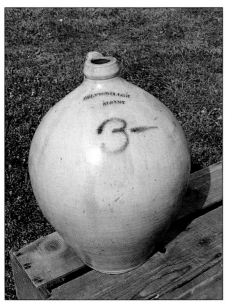

Three-gallon jug, Bennington, Vermont, ovoid. $450–$600

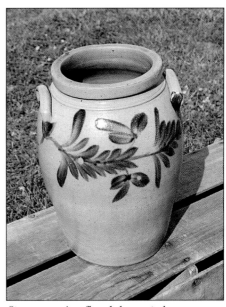

Stoneware jar, floral decorated. $425–$525

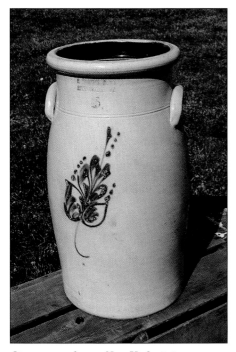

Stoneware churn, New York state. $450–$575

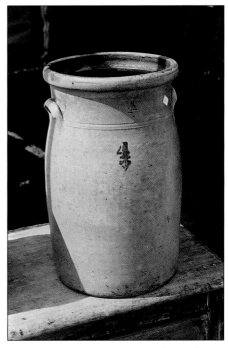

Four-gallon stoneware churn. $300–$385

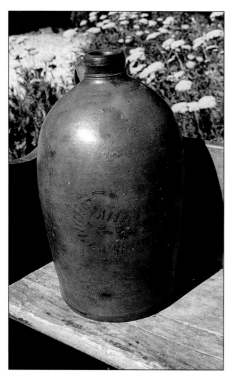

Jug, Pennsylvania, stenciled decoration.
$240–$285

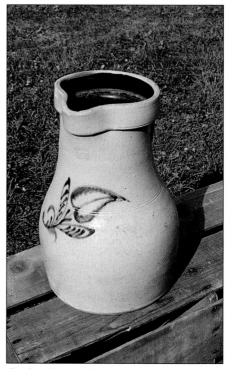

Pitcher, New York state, decorated.
$600–$700

AVAILABILITY: A piece of this quality would be difficult to find outside the ranks of the leading stoneware dealers or periodic high-end auctions.

INVESTMENT POTENTIAL: A piece of this quality can sustain more chips, cracks, and bumps than more commonly found examples of decorated stoneware and still increase in value each year.

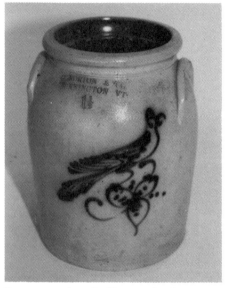

Stoneware jar, J. Norton & Company, Bennington, Vermont, detailed slip-trailed cobalt bird, original condition with no damage.

AVAILABILITY: The condition of this example is uncommon. Bennington pieces have a universal appeal to stoneware collectors and are difficult to locate. A major stoneware or Americana dealer might have a piece of this quality in his/her inventory.

INVESTMENT POTENTIAL: The potential for escalation in price is high because of the Bennington mark, the detail of the bird, and the condition of the piece.

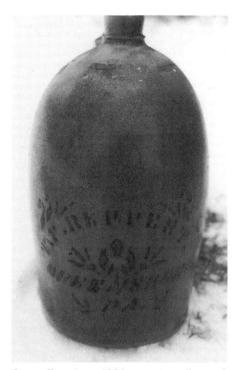

One-gallon jug, 1880s, western Pennsylvania, stenciled.

AVAILABILITY: Pennsylvania stoneware dealers would be the best source. The lack of decoration makes the piece less desirable to some collectors and dealers. Becoming more difficult to find each year and less common than crocks or jars.

INVESTMENT POTENTIAL: Especially high in Pennsylvania and becoming more appealing to new collectors as detail-decorated pieces are no longer readily obtainable. The long-term investment potential for pieces in exceptional condition is positive.

Collector's Checklist

Whether you're shopping for stoneware at an antiques show, market, or shop, use the following list to check the attributes and condition of any piece you're interested in *before* you buy it.

Type of stoneware piece
- [] Crock
- [] Churn
- [] Cooler
- [] Jar
- [] Jug
- [] Pitcher
- [] Specialty Piece
 - [] Bank
 - [] Batter Pail
 - [] Cooler
 - [] Flask
 - [] Milk Pan
 - [] Mug
 - [] Spittoon

Maker of the Piece
- [] Signed or marked
- [] Unsigned or not marked
- [] Especially rare mark

Age of the piece
- [] Late eighteenth or early nineteenth century
- [] 1830s–1840s
- [] 1850s–1860s
- [] 1870s–1880s
- [] 1890s–early 1900s
- [] After 1920

Color of the clay

Method of construction
- [] Molded
- [] Thrown on a potter's wheel

Damage
- [] Chips
- [] Cracks
 - [] Hairline
 - [] Major
- [] Discoloration
- [] Flaking of cobalt decoration
- [] Pebble bursts
- [] Repairs
 - [] Yes
 - [] No
 - [] Quality of repair
 - [] Sealed with glue
- [] Salt tears
- [] Stains

Decoration
- [] Type
 - [] Animals
 - [] Birds
 - [] Flowers
 - [] Geometric
 - [] Number (capacity mark)
 - [] Patriotic
 - [] People
 - [] Scenes
 - [] Swirls
- [] Size and detail
 - [] Depth of the cobalt color
 - [] Overall proportion in relation to the size of the piece of pottery
- [] Method of application
 - [] Brushed
 - [] Combination of brush and stencil
 - [] Incised or impressed
 - [] Slip cup
 - [] Stamped
 - [] Stencil

CHAPTER FOUR
Molded Stoneware

Collectors of country antiques have been interested in decorated stoneware since the 1950s. At one time it was easy to find a piece of reasonably priced early pottery in most antiques shops in the Midwest, Pennsylvania, New York, and New England. When prices gradually began to approach three figures, some collectors balked and tried to find a new direction for their stoneware pottery collecting.

At this point—the late 1960s—few people took an interest in molded stoneware because it was too common, too utilitarian, and too cheap for serious collectors.

Now and then a unique piece surfaced at a garage sale or a farm auction. Prices were far below those of hand-thrown pieces of stoneware. A nice stenciled cake crock could be found for $25 or less. Unusual pieces did not regularly turn up because the owners did not feel the need to clean out their basements, sheds, or chicken houses for examples that would bring only a few dollars.

In the early 1970s, magazines began to feature the country look and would occasionally illustrate a molded crock, jug, or bowl. A new group of collectors became interested in molded ware, and prices began to climb.

Historical Perspective

Illinois had many potteries at the turn of the century because of the many veins of clay in the state. To produce fine stoneware, a pottery needed a source of high-quality white clay. Sites in Ohio, Illinois, New Jersey, New York, and the New England coast were capable of handling the needs of many local potteries.

During the last half of the nineteenth century, stoneware began to be replaced by mass-produced tin and glass containers. For the most part, stoneware production ended in the early 1900s, but some isolated operations managed to hang on into the 1950s.

In the 1870s and 1880s, molded stoneware became a more common sight. The industry that produced molded ware was more mechanized than the older industry which turned clay by hand on a potter's wheel.

Much of the molded pottery had minimal decoration, and only about ten percent was signed or marked. Stencils were a common form of decoration— they were both quick and easy to apply. A capacity mark could be put on the piece, along with a wholesaler's name or the name of the manufacturer.

Making molded pottery probably was much like working in an assembly plant, but, on occasion, pottery workers would make special pieces for friends or loved ones. These are usually called "whimseys" or "end-of-the-day" pieces and may be unusual doorstops, pigs, frogs, or pipes. These one-of-a-kind items are typically expensive and fairly rare.

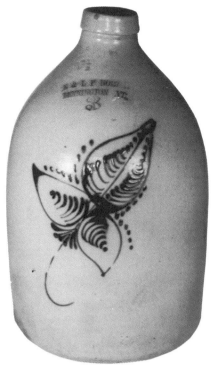

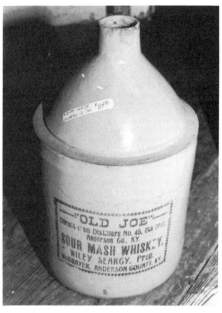

This "shelf" or "porch" jug has the cylindrical sides representative of molded stoneware of the period. *$100-$135.* By 1900 most stoneware jugs were molded, covered with a Bristol glaze, stenciled, and then delivered to the distillery that ordered them.

Three-gallon E. and L. P. Norton jug (1861–1881) with slip-trailed orchid. *$200-$300*

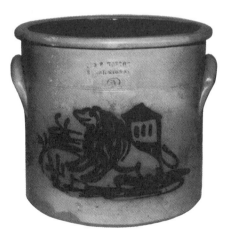

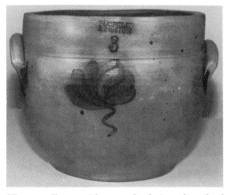

Three-gallon wide-mouthed jar, brushed flower blossoms, N. C. Bell of Kingston, New York, 1830–1834. *$335-$365*

J. and E. Norton (1850–59) crock with elaborate lion, house, and fence scene. *$6000-$9000*

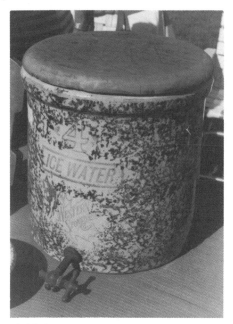

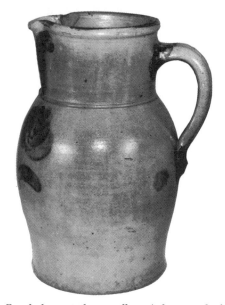

Brush-decorated one-gallon pitcher, marked "P. Herman," c. 1870. *$700–$900*

Molded stoneware ice-water cooler, Western Stoneware Co., Monmouth, Illinois, first quarter of the twentieth century. *$300–$350.* This four-gallon cooler was covered with a white or Bristol glaze and then decorated with a sponge dipped in cobalt. The stenciled capacity mark, "ice water," and maker's logo are indicative of many pieces of the period.

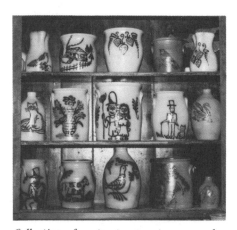

Collection of contemporary stoneware decorated with a slip cup from the Beaumont Pottery of York, Maine.

Bristol-glazed stoneware kitchen storage jar, early twentieth century. *$50–$55*

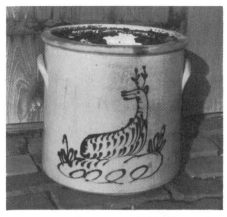

Edmonds and Co. slip-trailed deer on a three-gallon crock, Boston, Massachusetts, 1860s. $2000-$2400. The zebra-striped deer was also done by decorators at the J. and E. Norton Pottery of Bennington, Vermont. The Bennington deer usually was surrounded by pine trees and a post-and-rail fence.

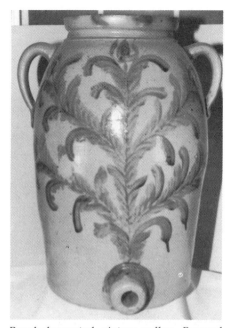

Brush-decorated sixteen-gallon Pennsylvania water cooler, unmarked, c. 1860; cooler has the same elaborately brushed cobalt tree on its reverse side. $3000-$3800

Unmarked molded stoneware mug, c. 1885, probably from Whites Pottery of Utica, New York. $30-$50

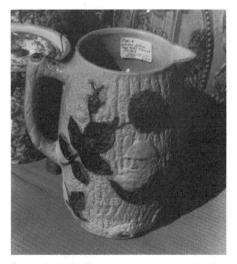

Late nineteenth-century stoneware pitcher with applied molded decoration. $100-$200

Molded pitcher, brown grapes on trellis design made by several potteries, including Ubl of Huntingburg, Indiana and Whitehall of Illinois, c. 1915. $100-$125

Western Stoneware Factory, Sleepy Eye mug, Monmouth, Illinois, c. 1920. $375-$425

Pitcher, brown grapes on trellis, unmarked, probably Ubl or Whitehall, 8½", c. 1915. $100-$125

34

Molded pitcher, brown, midwestern, 8″, c. 1900. $95–$115

Molded pitcher, brown glaze, unmarked, 9″, c. 1920. $60–$75

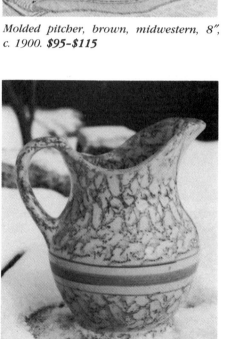

Pitcher, sponge decorated, unmarked, 7″, late nineteenth century. $175–$240

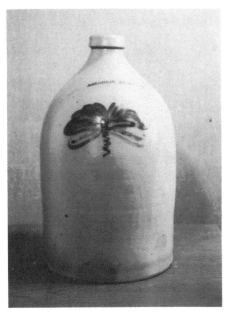

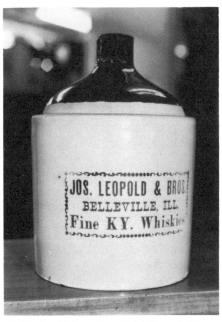

Stoneware jug with brushed decoration, mid-nineteenth century. $275-$325

Molded whiskey jug, Bristol and Albany slip glaze, c. 1890. $100-$125

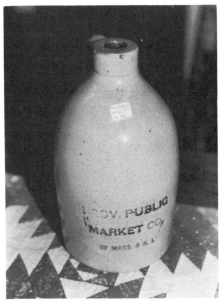

Bristol-glazed stoneware jug, stenciled label, c. 1900. $65-$75

Molded vendor's jug, stenciled label, c. 1900. $65-$75

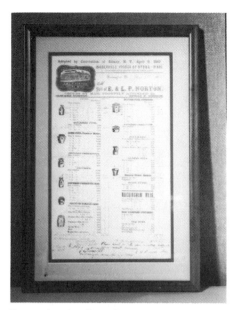

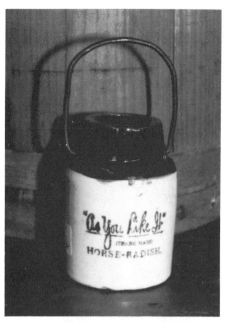

Framed price list of E. and L. P. Norton Pottery (1861-1881) at Bennington, Vermont. $400-$600. Most of the potteries developed extensive price lists of their products and distributed them in the limited geographic area they served. Very few have survived today, so collectors must search diligently to locate one.

Molded "As You Like It" horseradish container, c. 1900. $55-$65

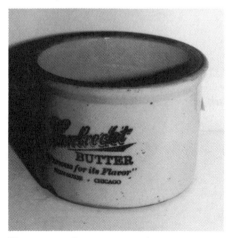

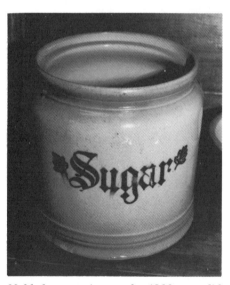

Molded sugar jar, early 1900s, no lid, $60-$70

Stoneware butter container, c. 1930. $25-$40

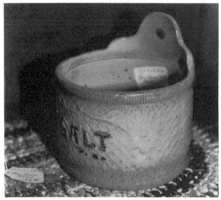

Molded salt jar, 1890-1915, no lid.
$135-$150

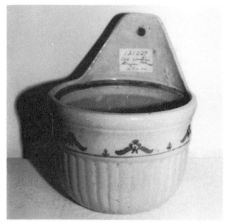

Molded storage jar, 1900-1915, no lid.
$200-$225

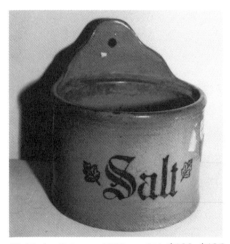

Molded salt jar, c. 1900, no lid. **$100-$125**

Unusual "thrown" jug, Albany slip glaze, 1880-1900. **$110-$125**

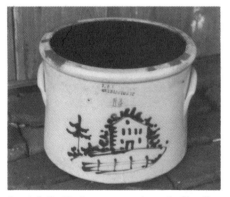

J. and E. Norton one-and-one-half-gallon crock, rare "house" scene. **$2000-$3000**

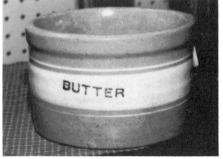

Butter crock, molded, c. 1900. **$100-$115**

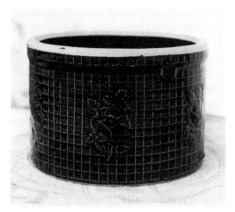

Molded butter crock, brown, unmarked, early 1900s. $60-$75

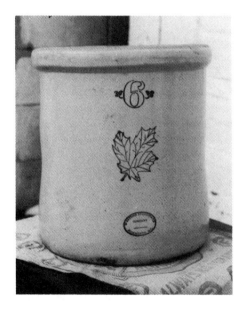

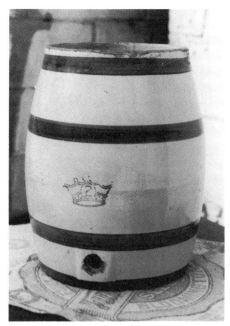

Cooler with Bristol glaze and blue bands, early 1900s. $100-$135

Western Stoneware Factory, six-gallon crock, molded, Bristol glaze, Monmouth, Illinois, early 1900s. $50-$65

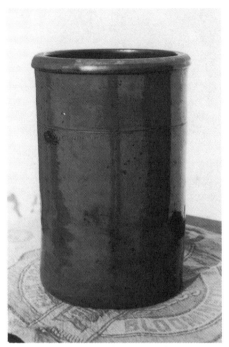

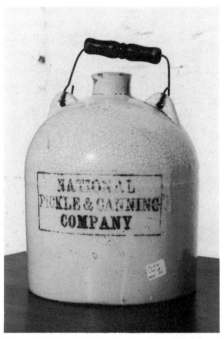

Stoneware jar, molded, Albany slip glaze, unmarked, 7", c. 1900. $50-$60

Jug with "drop" handle from the National Pickle and Canning Company, Bristol glaze, c. 1915. $50-$75

One-gallon jug, molded, Albany slip glaze, unmarked, early 1900s. $50-$65

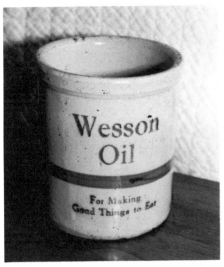

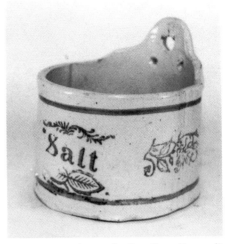

Stoneware salt crock, "as found" condition, stenciled decoration. **$50-$65**

Molded Wesson Oil jar, stenciled label. **$150-$175**

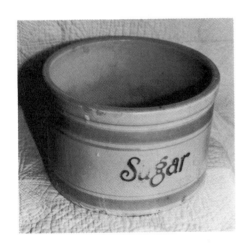

Molded stoneware sugar bowl. **$125-$150**

Molded stoneware butter crock, stenciled label, Bristol glaze. **$100-$125**

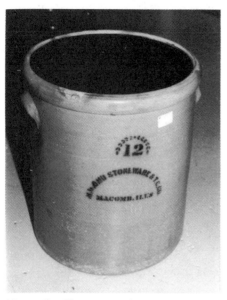

Molded stoneware doorstop, c. 1900.
$225-$275

Macomb, Illinois, twelve-gallon stone-ware crock, stenciled label, early 1900s.
$115-$145

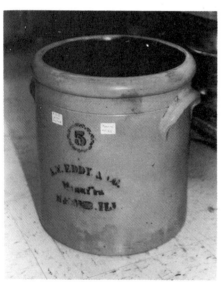

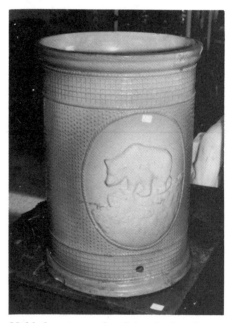

A. W. Eddy five-gallon crock, stenciled label, early 1900s. $100-$135

Molded water cooler, late nineteenth century. $300-$385

Mixing bowl, sponge decorated, unmarked, 7″ diameter, c. 1920. **$35–$45**

Mixing bowl, Rockingham glaze, unmarked, 7″ diameter, c. 1880. **$100–$125**

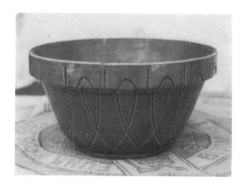

Ware Pottery, mixing bowl, molded, 5″ diameter, c. 1920. **$35–$45**

Mixing bowl, Rockingham glaze, unmarked, 6″ diameter, c. 1880. **$100–$125**

CHAPTER FIVE
Buying at Auction

Prices and Condition

As is the case with any item for which the demand is growing and the supply is decreasing, decorated stoneware is escalating in value. Stoneware was a product of the nineteenth century. Examples that were individually thrown on a potter's wheel and heavily decorated with cobalt slip are difficult to find.

Condition is a major factor in evaluating a piece of stoneware. It is crucial to remember that stoneware was utilitarian and not produced to be decorative. Crocks and jugs were in daily use and periodically suffered some damage. There are also very few pieces that emerged from the kiln without some kind of cosmetic damage ranging from discoloration to pebble bursts.

Obviously, damage takes a negative toll on decorative stoneware. Generally, less elaborately decorated pieces take major dips in value when accompanied by semi-serious chips or cracks. A spectacular jug with a cobalt horse standing in a meadow can have serious damage or major repairs and still demand big dollars because of its rarity and desirability.

The Waasdorp Stoneware Auctions

Bruce and Vicki Waasdorp conduct semi-annual stoneware auctions and provide profusely illustrated catalogues for potential bid-

ders. Bidding is done by telephone, fax, or mail.

The fifteen pictured pieces that follow were sold at auction in March of 1994. The actual auction selling price is given for each piece. As noted previously, condition is a major factor in the pricing structure and condition of each piece is accurately described. Also following is a list of pieces sold at the October 1994 auction. Information about these semi-annual auctions may be obtained by contacting:

Bruce and Vicki Waasdorp
Box 434
Clarence, NY 14031
(Fax) 716-759-2397
(Phone) 716-759-2361

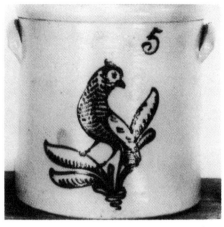

John Burger Jr., Rochester, New York, five-gallon crock with thick blue, slip-decorated, dotted bird. Professional repair to line in the side. Great example of an uncommon decoration, 12½", c. 1880. **$1000**

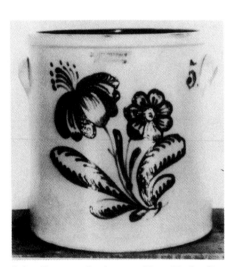

John Burger, Rochester, New York, five-gallon crock with three dimensional, dark blue double floral design, 6" tight line left of the decoration, otherwise excellent condition, 13¼". **$1250**

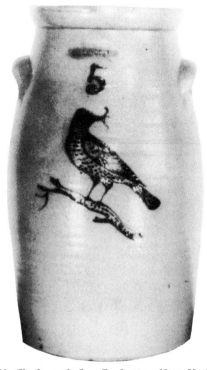

N. Clark and Co., Rochester, New York, five-gallon churn with heavy and dark blue cobalt. Professional restorations to age lines in back and through decoration, 17", c. 1850. Minimum bid was **$4500**

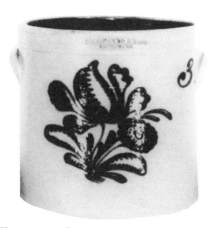

Harrington & Burger, three-gallon crock with heavy, dark blue cobalt, double flower. Some line staining, otherwise excellent condition, 10¼", c. 1853. $1550

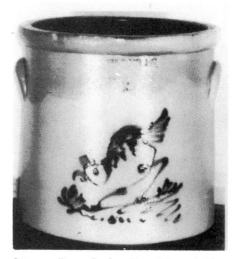

Ottman Bros. & Co., Fort Edward, New York, three-gallon crock, chicken pecking corn, 4" tight line in back and rim chip on side, 10½", c. 1875. $575

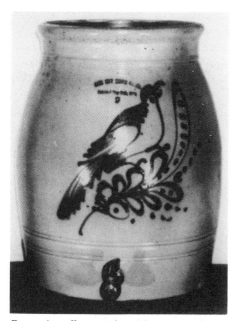

Rare six-gallon cooler, "Gate City Water Cooler Patented May 25th 1886," original lid impressed "ICE". Large slip bird on plume design. Original spigot. Very tight 4" line to the right of the plume and 2" line to the left of the bird, neither of which go through the decoration, 15". $875

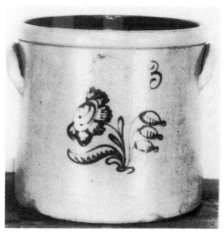

J. Burger Jr., Rochester, New York, three-gallon crock with slip daisy and buds. Inverted V through the line at base, otherwise excellent condition, 10¼", c. 1885. $110

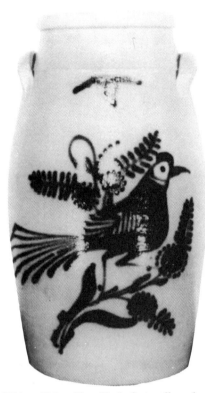

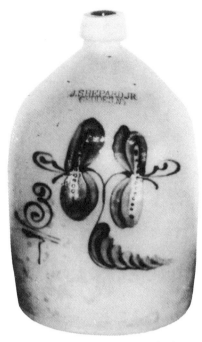

J. Shepard Jr., Geddes, New York, three-gallon jug with brush and slip-decorated double flower. Excellent condition, 14½", c. 1860. $375

Whites, Utica, New York, five-gallon churn with large, slip-decorated running bird and flowers. Some very minor design fry and stone ping on the side, otherwise excellent condition. Exceptional example of a very desirable design, 17½", c. 1865. $3700

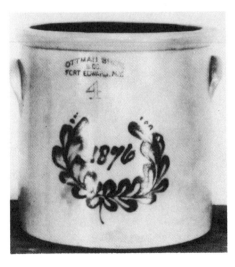

Ottman Bros. & Co., Fort Edward, New York, four-gallon crock with centennial date 1876 in wreath. Stack mark from manufacturing, professionally repaired tight lines on side and back, 11½", c. 1876. $375

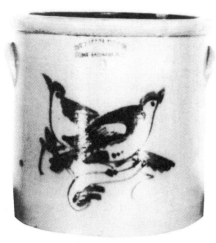

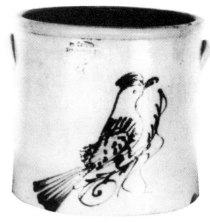

Ottman Bros. & Co., Fort Edward, New York, six-gallon crock with wonderful and large crossed double birds. Interior rim chips and lime stains, otherwise excellent condition. Very appealing and desirable, 13", c. 1870. **$1050**

D. Weston, Ellenville, New York, three-gallon crock with thick blue bird. X-shaped crack through line in middle of back. Rim chip above right ear, 10", c. 1860. **$290**

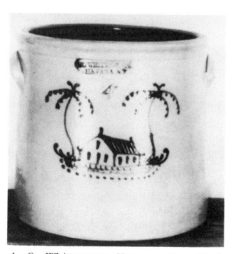

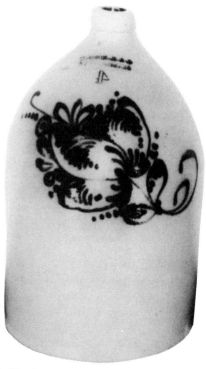

A. O. Whittemore, Havana, New York, four-gallon crock with house and palm tree design. Stabilized V-shaped crack on back. Exceptional example of a very rare design. Nice, dark blue cobalt, 11", c. 1865. **$2600**

P. Mugler & Co., Buffalo, New York, two-gallon ovoid jug with double flowers. Professional repair to chip in spout, 14", c. 1850. **$600**

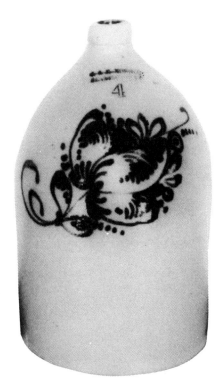

J. & E. Norton, Bennington, Vermont, four-gallon jug with vivid blue floral decoration. Excellent condition, clean and appealing, 17", c. 1855. $575

Auction Prices from October 1994 Waasdorp Stoneware Auction

Clarence, New York

1. Unsigned one-gallon pitcher with detailed double-flower design. Spout accented with unique dots and lines. A few minor age spiders in back. Attributed to Geddes Factory, New York, 9½" tall, c. 1850. **$400**

2. Unsigned one-gallon wide-mouthed jug with simple brush design. Unusual wax-seal opening. No damage, 10" tall, c. 1860. **$60**

3. Jordan one-gallon ovoid jug with brush design. Nice form and rather uncommon mark, very minor staining, otherwise excellent condition, 11½" tall, c. 1840. **$110**

4. Farrington, Elmira, New York, one-gallon jug with "Geo. N. Mura" in blue script, excellent condition, 10½" tall, c. 1890. **$90**

5. Cooperative Pottery Co., Lyons, New York, with "M. H. Brown, Brookfield NY" in script. Minor overall staining. Repair to both minor spout chip and age spider in the back, 10¾" tall, c. 1900. **$100**

6. Whites, Binghamton, New York, one-gallon jug with beautiful, vivid blue poppy decoration. Excellent condition, 11" tall, c. 1885. **$475**

7. Roberts, Binghamton, New York, one-gallon jug with detailed bird on branch looking backward. Vivid blue with professional restoration to spout chip and line in back, 11½" tall, c. 1860. **$600**

8. W. H. Farrar & Co., Geddes, New York, one-gallon jug with finely detailed bird and sunflower design. Lots of ground cover on this very desirable piece. A few insignificant glaze flakes, 11" tall, c. 1860. **$3,200**

9. Ithaca, New York, one-gallon ovoid crock with slip-decorated parrot design. Tight 5" Y-shaped through line in side and minor line in base on front. Uncommon mark, 8½" tall, c. 1865. **$325**

10. L. H. Wand, Olean, New York, two-gallon jar with geometric slip decoration, cinnamon-colored clay and rather uncommon mark, very minor hairline and rim chip, 11½" tall, c. 1860. **$150**

11. Whites, Utica, New York, four-gallon crock with running bird on plume, cinnamon-colored clay. Unusual trophy

accenting name and size. Professional restoration to glaze flaking on side and rear, glued chip on side, and minor hairlines in rim, 11½″ tall, c. 1865. **$300**

12. N. A. White & Son, Utica, New York, two-gallon crock with bright drooping orchid decoration. Insignificant surface rim chip and glaze spider, 9″ tall, c. 1885. **$190**

13. Whites, Utica, New York, 3-gallon jar with vivid cobalt orchid, very minor design fry and minor surface chips on left ear, 13″ tall, c. 1865. **$270**

14. N. A. White & Son, Utica, New York, four-gallon paddle tail and plume decoration. Professional restoration to both rim chip and Y-shaped crack in blue, 11½″ tall, c. 1885. **$700**

15. "Union Pottery, J. Zipp, Prop. New Jersey," four-gallon crock dated "1886," 6″ tight through line in front, slight discoloration in firing, 1″ hairline in back, 11″ tall. **$280**

16. Lyons, New York, two-gallon preserve jar with double flower and double "1" in blue, accents under the ears, tight spider line in front, rim chips on side, 10¾″ tall, c. 1860. **$150**

17. Lyons, New York, one-gallon jug with simple blue brush decoration. Overall staining otherwise excellent condition, 11″ tall, c. 1860. **$80**

18. Lyons, New York, two-gallon preserve jar with brushed decoration, repair to rim chip and stone ping in the making, stack marks in the making, 12″ tall, c. 1860. **$100**

19. T. Harrington, Lyons, New York, three-gallon crock with slip-decorated sunflower design, nice detail in this flower. Professional repair to age lines in front and back, not going through blue, 10¼″ tall, c. 1855. **$475**

20. Lyons, New York, three-gallon jug with large ribbed flower executed in slip and brush, excellent condition, 16½″ tall, c. 1855. **$625**

21. H. Purdy four-gallon ovoid jug with blue brush design and accents at the top of the handle, professionally restored handle, otherwise excellent condition, 16″ tall, c. 1840. **$150**

22. Edmonds and Company two-gallon jug with dotted bird on a branch, excellent condition, 14″ tall, c. 1865. **$600**

23. F. B. Norton and Company, Worcester, Massachusetts, three-gallon crock with dark blue parrot on a plume, good blue, replaced right ear, restorations to extensive lines in back, 10″ tall, c. 1870. **$270**

24. Burger and Lang, Rochester, New York, six-gallon crock with large slip-trailed daisy. Long, tight stabilized hairline in back, otherwise excellent condition. Appealing, large piece, 14″ tall, c. 1870. **$500**

25. Harrington and Burger, Rochester, New York, two-gallon jug with vivid blue sunflower. Slightly blurred, but a great example. Very minor design fry, stack mark, otherwise excellent condition, 14½″ tall, c. 1852. **$725**

CHAPTER SIX

Interview with Dick Thompson

Dick and Kay Thompson sell American antiques at shops in the Holiday House in downtown Pontiac, Illinois, and at the Chenoa (Illinois) Antiques Mall. Both businesses are readily accessible from Interstate 55 in the heartland of Illinois. The Thompsons may be reached at (815) 842-2586.

Q. What do today's stoneware collectors want?

A. It has been my experience that there are two distinct types of stoneware collectors with which I have contact. There are serious collectors of Eastern stoneware who are primarily interested in extensive and unique cobalt decoration. They pay some attention to the maker's mark but they will pay for elaborately decorated pieces.

There are also a lot of regional collectors who are interested in obtaining pieces from specific potteries that usually are relatively close to their home area or state. For example, I see collectors paying hundreds of dollars for a salt-glazed and cobalt-decorated piece from the Peoria, Illinois, Pottery that would not bring $150 in Maine or New York. Western Pennsyl-

53

vania pottery is worth more in Western Pennsylvania than any-where else on earth.

New York State and New England stoneware pieces have a comparable value in California and in Maine or Vermont.

Q. How difficult has it been to sell stoneware?

A. In the last year or two the market has been very "soft" for mediocre pieces of stoneware. Casual collectors will buy a piece if they need something to put the dog's food in or if a reasonably good piece is unusually cheap. Great pieces of any type of Americana sell well if they are in good condition. They sell quickly because they are so difficult to find. Collectors spend a great deal of time looking and they get fed up with what they see in the malls and jump on an exceptional piece when they have an opportunity to buy it if it's priced at close to what it is worth.

Q. Have reproductions created any problems for the stoneware market?

A. I have not found reproductions to be even a minor concern. I am much more concerned about pieces that have had extensive repair or retouching than I am about reproductions. Recently I saw a nine-teenth-century New York State crock that had originally nothing on it other than the maker's mark and a capacity mark. Someone had added a bird on a branch to the front of the crock and turned a $70 piece into one that was priced at $285. A serious collector would have laughed at it, but someone looking for their first good piece might have considered it a bargain and written the check.

I am convinced that someone eventually will find it profitable enough to develop techniques of decorating old pieces of stoneware that will fool even the most serious collectors.

Q. Is there a market for molded stoneware?

A. I see a lot of molded crocks that are still fairly inexpensive and there is not a lot of interest in them at this point. There are some pieces of molded stoneware like sponge-decorated pitchers, cake crocks, butter crocks, and flag holders that are difficult to find and expensive. There is a growing demand for quality pieces that date from about 1880 to 1915.

Q. If you were looking for a spectacular piece for your personal collection, where would your search begin?

A. If I was looking for a major piece of decorated stoneware that I wanted to own forever, I would contact one of the five or six major stoneware dealers in the United States. If they don't have what I want, they will put me in contact with someone who does or begin a search process themselves. Stoneware specialists understand the market and price their pieces accordingly. Seldom do they offer bargains, but you have no doubt about what you are getting when you buy from them.

CHAPTER SEVEN

Collecting Yellowware

Yellowware is a soft-bodied pottery defined by the color of the clay, which can vary from buff to pumpkin when fired. Yellowware was first produced in England and Scotland around 1780 and in the United States around 1830; it is still being produced today. The most desirable yellowware examples are the fairly primitive and mocha-decorated pieces produced between 1840 and 1930 in the United States and England.

Yellowware is usually covered by a clear alkaline or lead glaze, although sometimes the glaze will be yellowish in color. A lot of the yellowware produced was plain in design. Other pieces were decorated with various combinations of colored slip, mocha, and colored glazes. Most yellowware is not marked, which makes identifying the maker and place of origin very confusing.

While prices of all yellowware are on the rise, prices for mocha-decorated varieties have increased the most, nearly doubling over the past several years. The demand for yellowware and the scarcity of good pieces have necessitated the buying of repaired pieces. There is nothing wrong with buying a repaired piece of yellowware if the damage is reflected in the price and the person you are buying it from tells you it has been repaired.

Make it a point to weigh all factors carefully when buying a piece with a repair or one with more than minor damage, but remember that yellowware is a soft-bodied, utilitarian pottery that was used in the kitchen every day. It was not something that sat on a shelf for decorative purposes. It is unrealistic to think you can fill a cupboard with rare and wonderful items, all in "perfect" condition.

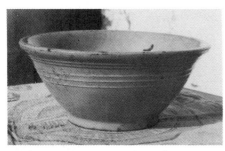

Yellowware mixing bowl, 7″ diameter, molded, unmarked, c. 1900. **$55-$60**

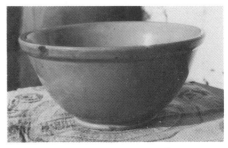

Yellowware mixing bowl, 9″ diameter, unmarked, c. 1900. **$45-$55**

Molded yellowware bowl. **$65-$75**

Sponge-decorated bowl. **$125-$150**

Banded and molded bowls vary in price from $35 to $200, depending on size.

Banded and molded bowls. $35-$200 each

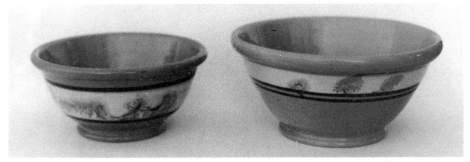

Mocha-decorated bowls. $250-$650 each. The price is largely determined by the size of the bowl and the amount of mocha on the slip band.

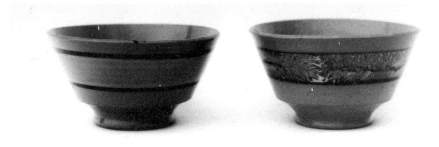

"Tea" bowls: banded, $95-$150; mocha, $275-$395.

PART II

Pictures and Prices

Unlike the pieces illustrated in Chapter Five that had detailed explanations of condition that ultimately affected their auction price, the pieces that follow are assumed to be pristine unless otherwise noted, and the values given reflect current market prices. It is important to realize that it is almost impossible to locate elaborately decorated stoneware in pristine condition.

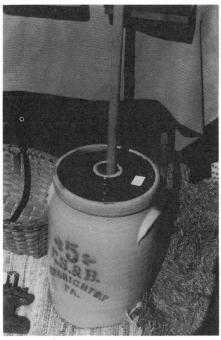

Stenciled New Brighton, Pennsylvania, butter churn with cylindrical sides, c. 1890.
$150-$185

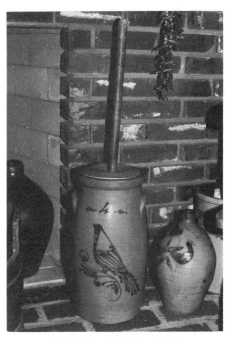

Four-gallon butter churn from the Fulton, New York, pottery of Samuel Hart that was in operation between 1840 and 1876.
$1700-$2200

Two-gallon John Burger, Rochester, New York, crock, deep cobalt lily, 1854-1867.
$325-$375

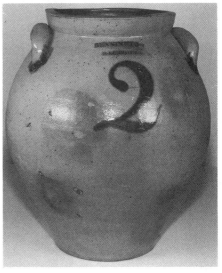

Ovoid two-gallon jar, c. 1823, Bennington Factory (Vermont), brushed "2," rare mark. **$1200-$1500**

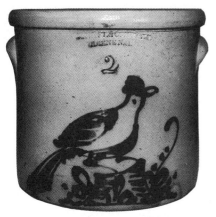

Two-gallon Keene, New Hampshire, crock from the Taft Pottery, 1880s. **$500-$700**

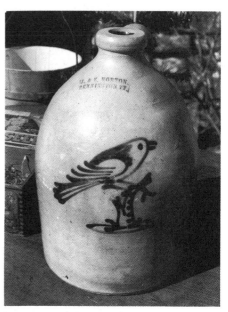

This J. and E. Norton jug dates from the 1850-1859 period of ownership. **$800-$1000.** *It is important to understand and be able to identify the gradual evolution of forms from ovoid to cylindrical.*

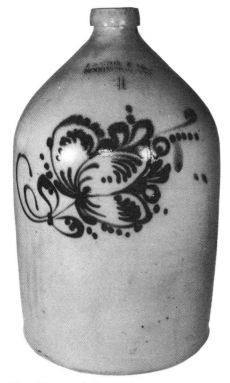

The slip-trailed floral spray on the four-gallon J. Norton and Co. jug carries a three-year mark (1859-1861). **$350-$425**

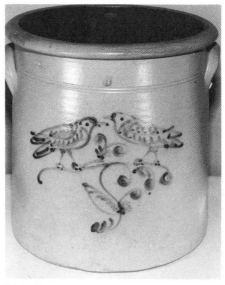

Six-gallon unmarked crock with a pair of spotted birds, c. 1875. **$600-$750**

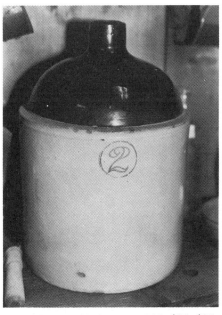

Two-gallon molded jug, c. 1900. **$30–$35**

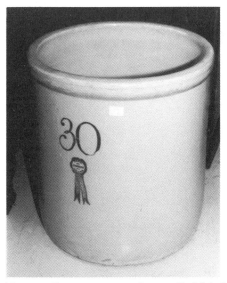

Thirty-gallon storage crock, stenciled label and capacity mark. Bristol glaze, early 1900s. **$75–$90**

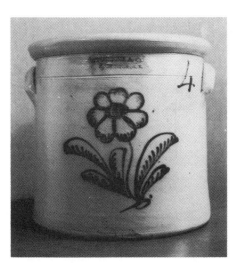

Burger and Company four-gallon crock, slip-trailed flower. **$375–$395**

Western Stoneware five-gallon crock, stenciled label and Bristol glaze, 1920s. **$65–$80**

Stoneware pickle container, early twentieth century. $150–$225

Three-gallon cooler, Bristol glaze with blue striping, late nineteenth century. $150–$175

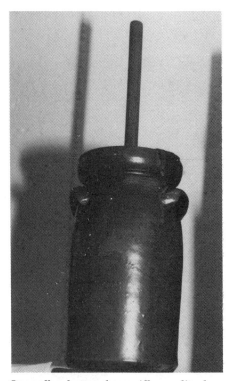

One-gallon butter churn, Albany slip glaze, c. 1900. $125–$150

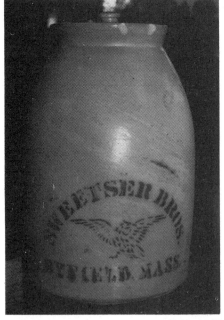

Stenciled canning jar, c. 1870. $200–$240

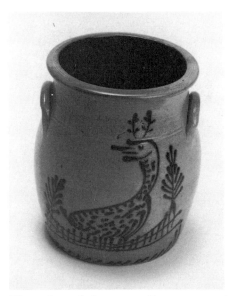

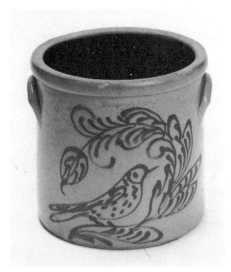

Edmonds and Co. crock, speckled bird with lots of leaves. **$1300-$1600**

Edmonds and Co., two-gallon cream pot with a reclining and spotted deer. **$3200-$3600**

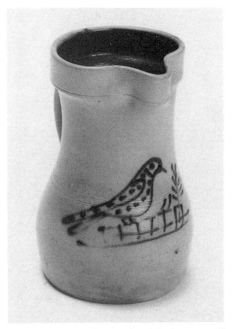

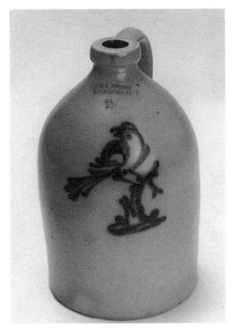

Two-gallon J. & E. Norton, Bennington, Vermont jug, bird on a stump, rare, heavy cobalt decoration. **$1300-$1500**

Edmonds and Co. bird with fence milk pitcher, uncommon. **$1800-$2000**

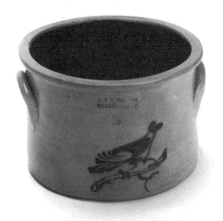

One-and-one-half-gallon Bennington, Vermont, crock, $700–$775

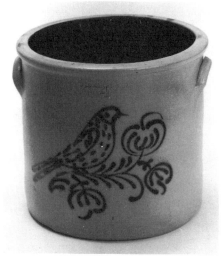

Edmonds and Co. four-gallon bird crock. $500–$700

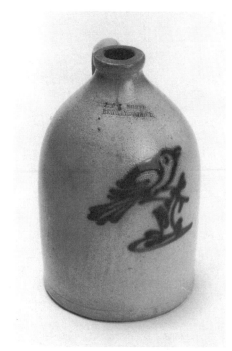

One-gallon jug, J. & E. Norton, Bennington, Vermont, bird on a stump. $800–$1000

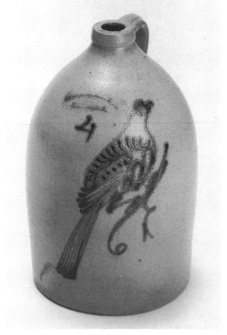

Four-gallon jug with long-tailed bird, probably from New York Stoneware Co., Fort Edward, New York. $650–$750

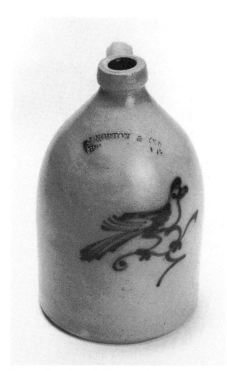

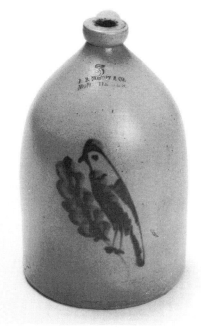

One-gallon jug, J. Norton Co. Bennington Vermont. $600-$700

Three-gallon jug, F. E. Norton and Co., Worcester, Massachusetts. $700-$800

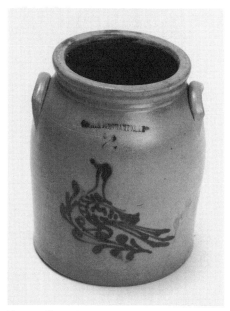

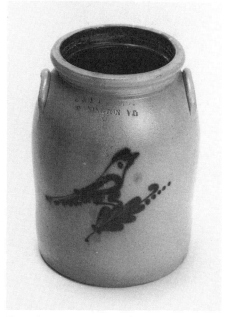

Two-gallon jar with bird, signed W. Roberts, Binghamton, New York. $600-$700

E. and L. P. Norton, Bennington, Vermont, jar. $500-$600

69

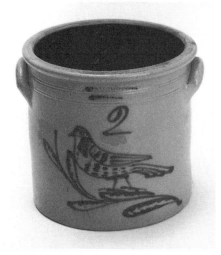

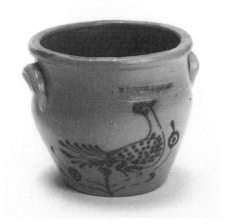

One-gallon W. Roberts jar with folksy bird.
$800-$1000

Two-gallon crock with bird, T. Harrington,
Lyons, New York. ***$1000-$1100***

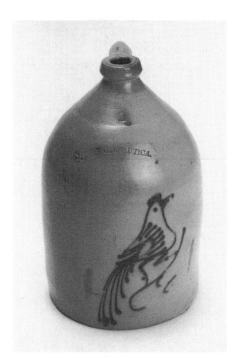

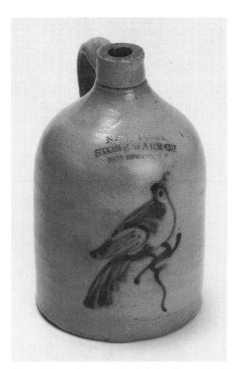

Two-gallon jug, Whites, Utica, New York,
cobalt bird. ***$500-$575***

One-gallon jug, with bird. New York
Stoneware Co., Fort Edward, New York.
$450-$550

70

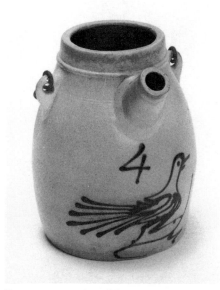

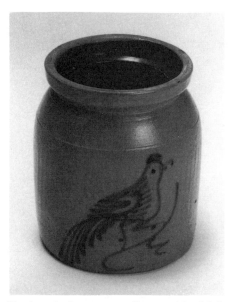

Four-quart unsigned batter jug, probably Whites, Utica, New York. $1000-$1200

Unsigned .jar, one-gallon, with bird. $500-$575

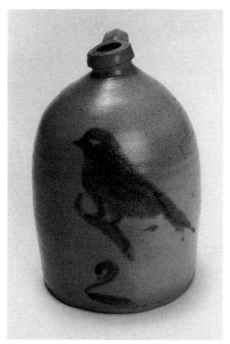

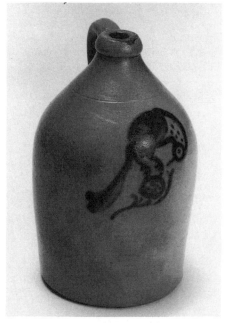

Unsigned two-gallon bird jug. $550-$650

One-gallon jug with unusual cobalt bird, unsigned. $500-$600

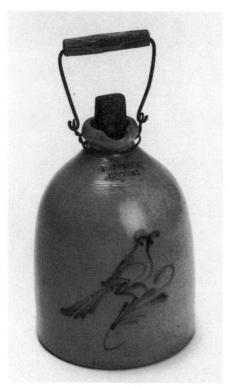

One-gallon West Troy, New York, whiskey jug with primitive decoration, handle and cork. *$500–$600*

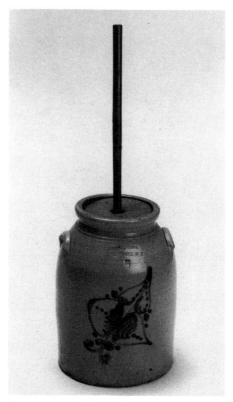

Five-gallon butter churn, Adam Caire. *$600–$750*

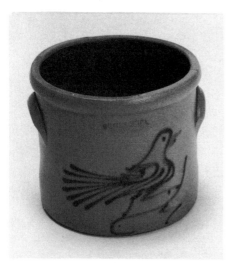

One-gallon crock with running bird, Whites, Utica, New York. *$550–$650*

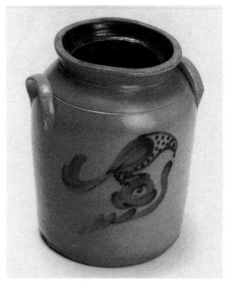

One-gallon jar with bird, unsigned. *$675–$850*

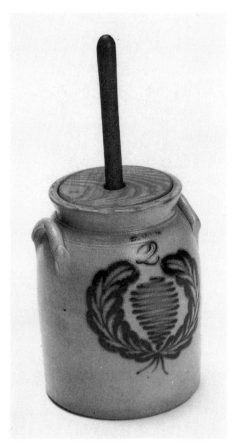

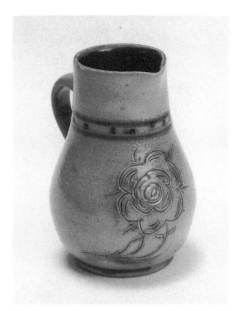

One-half-gallon incised Pennsylvania milk pitcher. **$800–$900**

Two-gallon butter churn with deep cobalt decoration, Lyons, New York. **$650–$750**

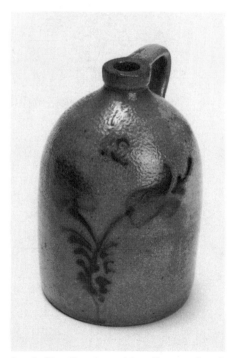

One-gallon butter crock with lid.
$450–$550

One-half gallon jug with tulips, unsigned.
$300–$385

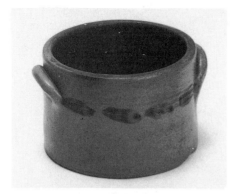

Small butter crock. **$300-$350**

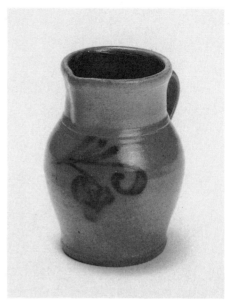

Small half-gallon milk pitcher. **$500-$600**

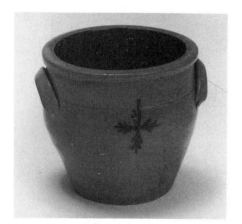

Six-inch jar, impressed "½" on opposite side. **$300-$400**

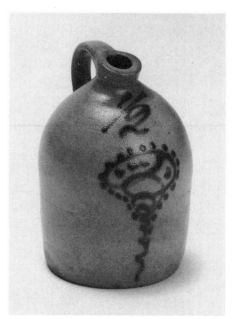

One-half gallon jug, slip-trailed decoration unsigned. **$300-$400**

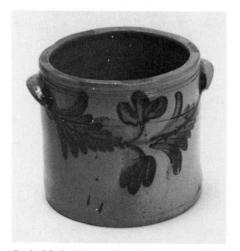

Probable butter crock or jar, unusual size, strong blue decoration. **$575-$650**

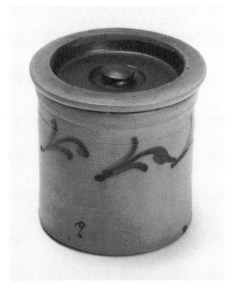

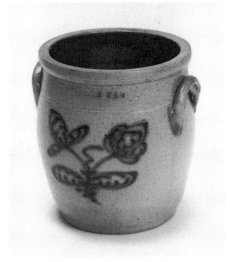

Small crock with lid. $300-$350

Cream pot with strong blue, Penn Yan, New York. $375-$425

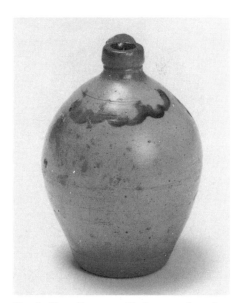

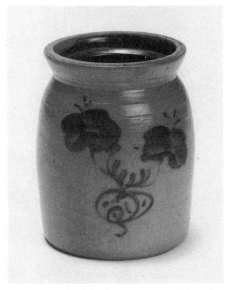

One-half gallon ovoid jug, early nineteenth century. $550-$650

Small jar, double flowers, strong blue decoration. $285-$350

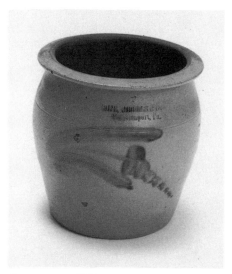

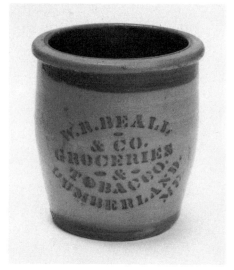

Cream pot, Williamsport, Pennsylvania.
$475-$525

*Store jar, W. R. Beall & Co., Cumberland,
Maryland.* **$500-$650**

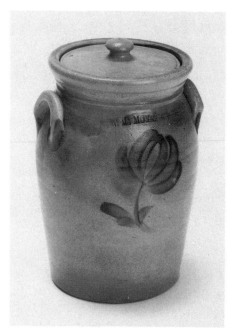

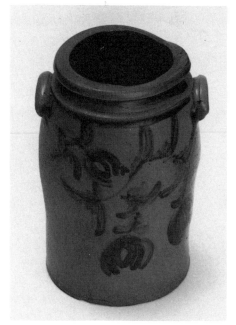

*W. Moyer jar with lid, brushed cobalt
design.* **$300-$350**

Three-gallon jar, Pennsylvania origin.
$475-$525

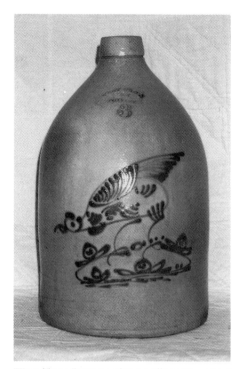

West Troy Pottery, three-gallon jug; great chicken pecking corn, cobalt decoration. *$1200-$1500*

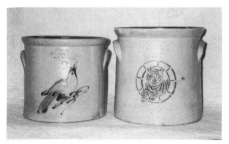

New York Stoneware Co., Fort Edward, New York, two-gallon crock, bird decoration, *$350-$450;* F. T. Wright and Son, Taunton, Massachusetts, stenciled blue crock, tiger design. *$200-$300*

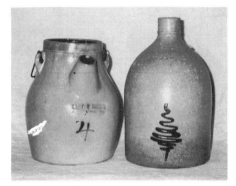

E. and L. P. Norton, Bennington, Vermont, four-quart butter pail, *$400-$500;* White's Utica, New York, one-gallon jug, pine tree decoration, *$150-$200*

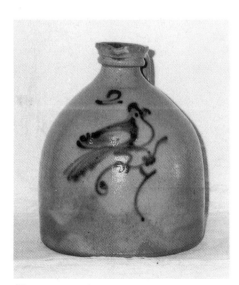

Uncommon batter jug with pouring spout, unsigned with bird decoration. *$500-$600*

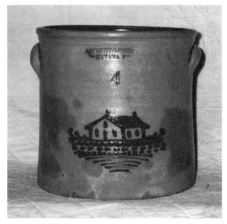

A. O. Whitmore, Havana, New York, four-gallon crock with rare house decoration. *$1800-$2300*

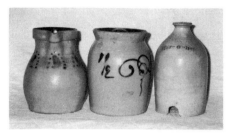

Unsigned one-half-gallon pitcher, $400-$500; one-half gallon unsigned preserve jar, $300-$400; "Peep-O-Day" chicken feeder, $50-$75

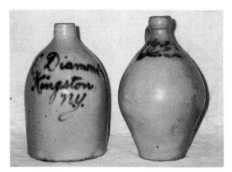

One-gallon advertising jug in blue script, $150-$200; one-gallon jug, ovoid, "1830" in blue, $300-$400

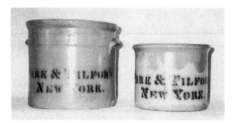

Two matching stenciled advertising crocks. $150-$200 each

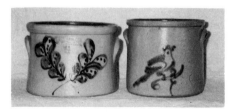

F. B. Norton, Worcester, Massachusetts, one-and-one-half gallon cake crock, rare size, $450-$550; unsigned one-gallon bird crock. $300-$400

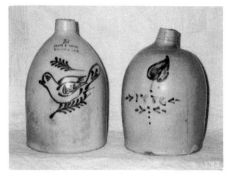

Frank B. Norton, Worcester, Massachusetts, two-gallon jug with deep blue dove decoration, $700-$900; Bosworth, Hartford, two-gallon jug, decorated, dated 1886, $450-$550

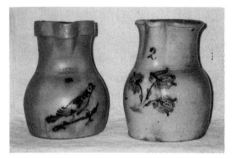

J. and E. Norton, Bennington, Vermont, two-gallon pitcher, rare design and size, repaired and restored, $350-$450; unsigned two-gallon pitcher, rare size, $650-$750

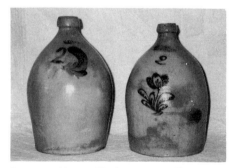

Lyons, New York, two-gallon jug, $150-$200; John Burger, Rochester, New York, two-gallon jug, $275-$375

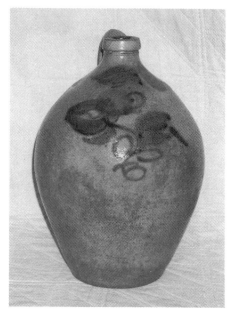

"Mead Ohio," two-gallon ovoid-shaped jug.
$300-$400

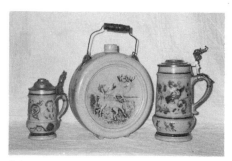

Selection of molded stoneware, c. 1900, White's Utica Pottery; small stein, $300-$400; canteen, $650-$750; large stein, $500-$600

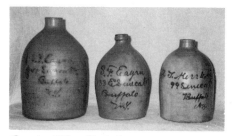

Group of New York State signed advertising script jugs. $150-$250 each

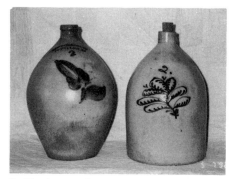

P. Mugler, Buffalo, New York, two-gallon jug, $450-$550; J. Burger Jr., Rochester, New York, $250-$350

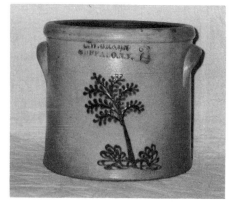

C. W. Braun, Buffalo, New York, two-gallon crock with unique tree design. $1500 and up

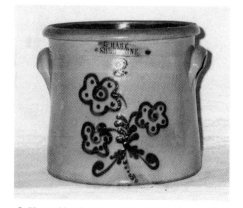

C. Hart, Sherbourne, New York, two-gallon crock with thick blue decoration. $325-$425

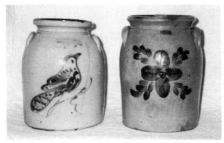

*Fort Edward Pottery Co. two-gallon jar with lid, **$450-$550**; "Lyons," New York, two-gallon jar with lid, **$450-$550***

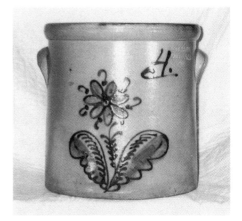

*C. W. Braun, Buffalo, New York, four-gallon crock, abstract flower. **$350-$450***

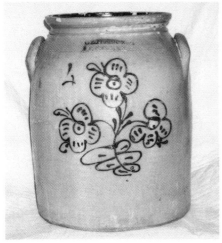

*W. H. Farrar, Geddes, New York, four-gallon preserve jar, detailed flowers. **$350-$450***

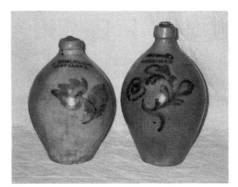

*Two early signed Buffalo, New York, ovoid jugs, c. 1840. **$450-$550** each*

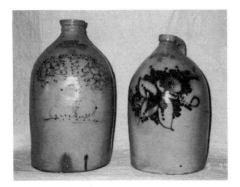

*J. Norton, Bennington, Vermont, five-gallon jug, large dark blue decoration, **$550-$650**; uncommon four-gallon store-marked jug with floral decoration, **$470-$575***

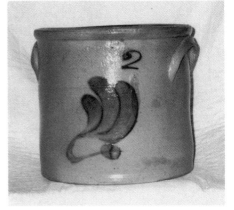

*J. Fisher, Lyons, New York, two-gallon crock. **$100-$150***

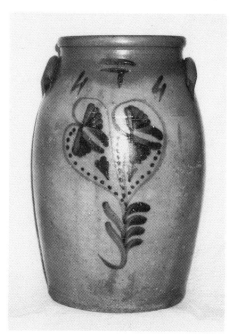

Rare signed Milwaukee, Wisconsin, four-gallon churn. $700-$900

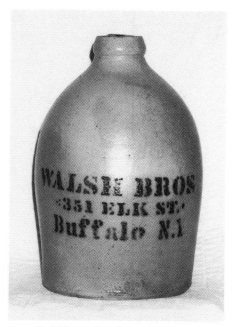

Stenciled blue advertising jug, one gallon. $150-$200

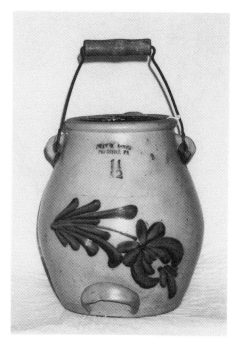

Evan R. Jones, Pittston, Pennsylvania, 1½-gallon bale-handled batter pail, large brushed flower design. $900 and up

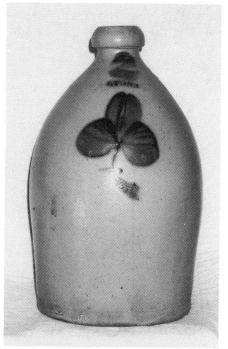

"Lyons," New York, two-gallon jug. $200-$300

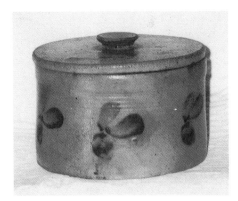

Unsigned approximately two-gallon cake crock with matching lid. **$400-$500**

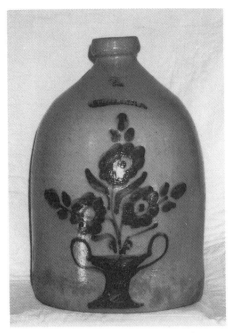

White's Utica, two-gallon jug with rare compote of flowers decoration. **$900-$1100**

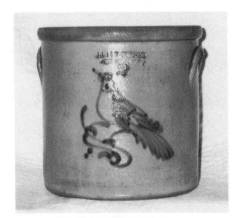

J. A. and C. W. Underwood, Fort Edward, New York, two-gallon crock with large bird. **$500-$600**

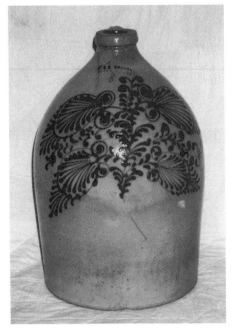

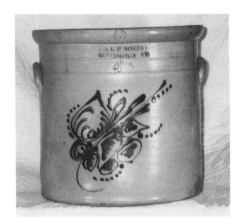

E. and L. P. Norton, Bennington, Vermont, four-gallon crock. **$500-$600**

J. E. Norton, Bennington, Vermont, three-gallon jug with large and elaborate floral design. **$1500 and up**

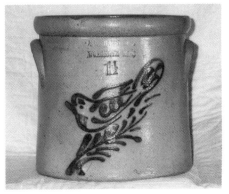

F. B. Norton and Sons, Worcester, Massachusetts, uncommon one-and-one-half gallon crock with blue dove decoration. $700-$900

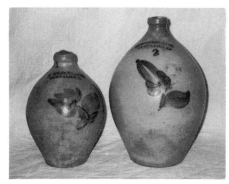

One- and two-gallon jugs with uncommon "P. Mugler, Buffalo, N.Y." mark and blue brush decoration. $450-$550

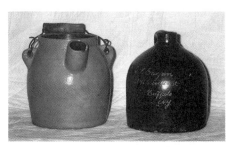

Olean, New York, one-half-gallon batter pail, bale handle, undecorated. $150-$250; unsigned one-half-gallon Albany slip brown jug with incised store advertising, $50-$100

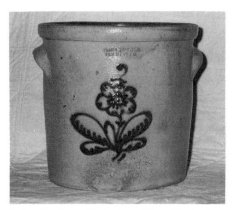

John Burber, Rochester, New York, two-gallon crock, daisy decoration. $400-$500

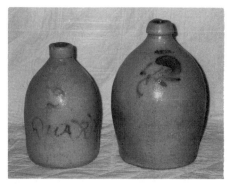

Unsigned jug with "2 quarts" in blue script, New York State origin, $250-$350; "Lyons" one-gallon jug with simple plume design, $150-$200

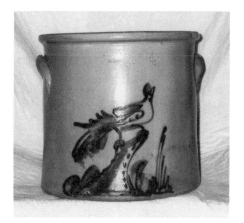

Riedinger and Caire, New York, four-gallon crock, long-tailed bird on a stump. $750-$950

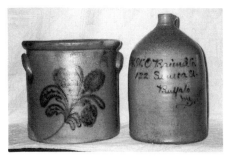

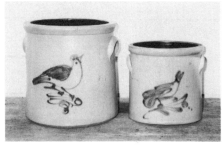

J. Fisher, Lyons, New York, five-gallon crock with a blurred flower design. $350-$450; unsigned two-gallon crock with store advertising in blue script, $150-$250.

Unsigned three-gallon crock, $275-$375; six-quart bird crock, $275-$375.

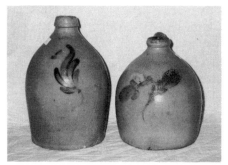

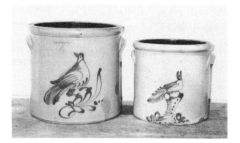

"Lyons," New York, one-gallon jug, $150-$200; unsigned one-gallon ovoid jug, $125-$175

Geddes, New York, four-gallon crock, large bird decoration, $700-$800; Brady and Ryan, Ellenville, New York, two-gallon bird on a stump crock, $700-$800

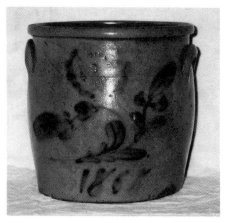

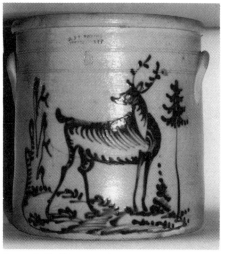

N. Clark and Co., Athens, New York, ovoid crock dated "1868" in blue. $650-$750

J. and E. Norton, Bennington, Vermont, five-gallon crock with elaborate standing deer decoration. $6000 and up

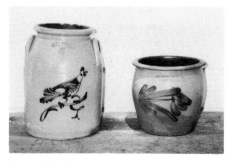

J. and E. Norton, Bennington, Vermont, two-gallon jar $700-$800; Cowden and Wilcox, Harrisburg, Pennsylvania, one-gallon cream pot, $225-$325.

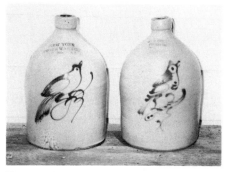

New York Stoneware, Fort Edward, New York, one-gallon jug with large bird, $500-$600; Fort Edward Pottery Co., one-gallon bird jug, $400-$500

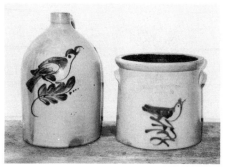

Unsigned three-gallon jug, New York State origin, $300-$400; unsigned three-gallon bird crock with impressed store advertising, $350-$450

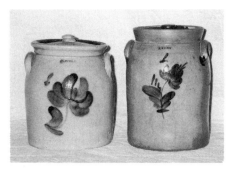

"Lyons," one-gallon lidded preserve jar, $300-$400; "Lyons," one-gallon lidded preserve jar, $300-$400.

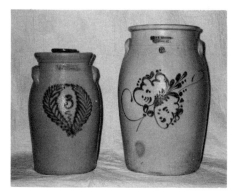

John Burger, Rochester, New York, three-gallon churn with wreath design, $400-$500; J. and C. W. Underwood, Fort Edward, New York, large six-gallon bulbous churn, $400-$500.

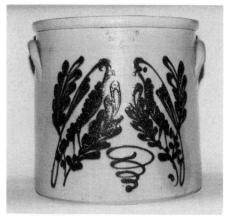

Fort Edward Pottery, five-gallon crock with elaborate and rare double bird and plumes decoration. $5000 and up

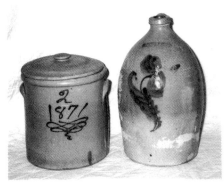

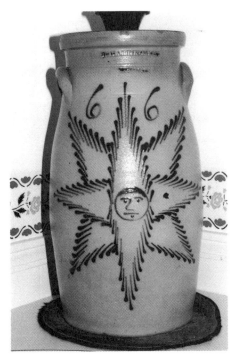

*Unsigned crock with "1871" in blue, with cover, Ohio origin, **$350-$400**; Hubbel and Cheboro, Geddes, New York, two-gallon jug, glaze worn off in spots, **$100-$150**.*

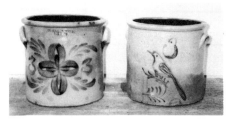

*T. Harrington, Lyons, New York, three-gallon crock with some grease staining. **$450-$550***

*T. Harrington, Lyons, New York, six-gallon churn with the eagerly sought "starface" decoration. **$4000***

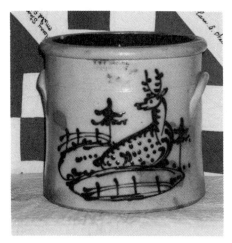

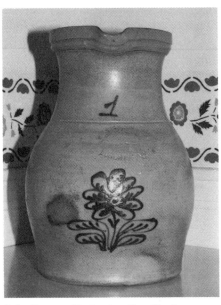

*J. and E. Norton, Bennington, Vermont, crock with rare dark blue reclining deer decoration. **$3700** and up*

*John Burger, Rochester, New York, uncommonly marked pouring pitcher. **$800** and up*

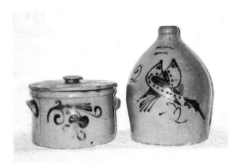

S. Hart, Fulton, New York, two-gallon jug with crossed love birds. **$900-$1200;** unsigned cake crock with matching decorated lid. **$650-$800**

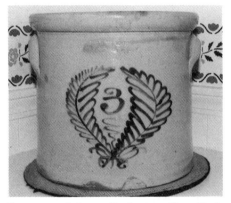

Burger and Lang, Rochester, New York, three-gallon crock with wreath design. **$275-$375**

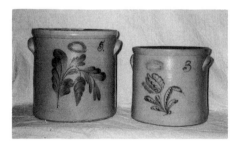

J. Burger Jr., Rochester, New York, five-gallon crock with grapes, **$400-$500;** J. Burger Jr., Rochester, New York, three-gallon floral decorated crock, **$350-$450**

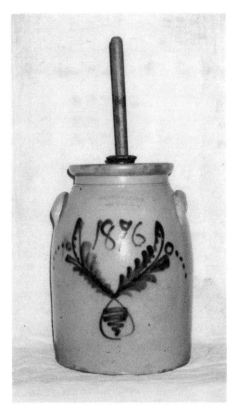

Riedinger and Caire, Poughkeepsie, New York, two-gallon table churn with the centennial date "1876" in blue. **$700-$900**

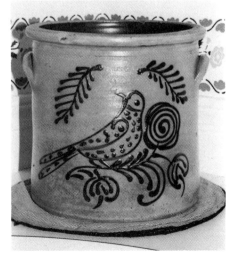

Elaborately decorated five-gallon crock with spotted bird. **$600** and up

87

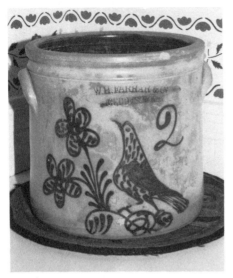

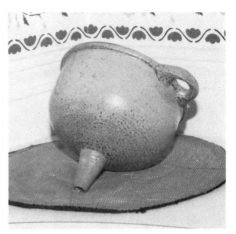

Rare unsigned stoneware funnel.
$100–$175

Two-gallon crock signed "W. H. Farrar, Geddes, N.Y." with bird and flower decoration. $1150–$1450

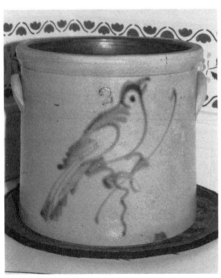

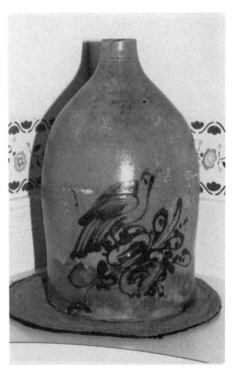

Unsigned two-gallon bird crock.
$275–$375

Fort Edward, New York, jug with large bird-and-plume decoration. $650–$850

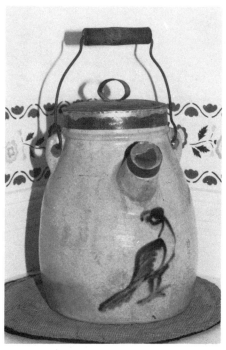

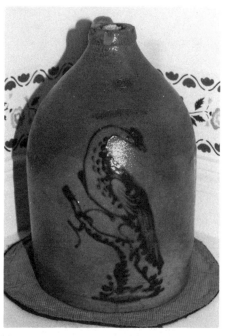

Unsigned batter pail with rare bird deco-
ration. $950–$1150

Two-gallon jug signed "Whites, Utica, N.Y."
with peacock-on-a-stump decoration.
$1200 and up

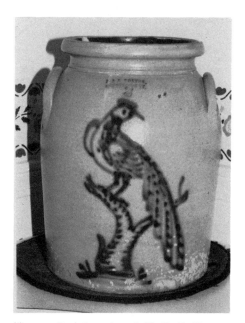

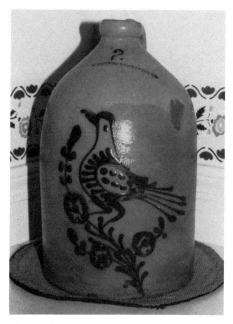

Three-gallon jar signed "J. & E. Norton,
Bennington, Vt." with rare peacock on a
stump. $1400 and up

Two-gallon jug signed "W. Roberts,
Binghamton, N.Y." with bird decoration.
$900–$1200

Selection of unsigned stoneware mugs attributed to the White's Utica factory. $100 and up each

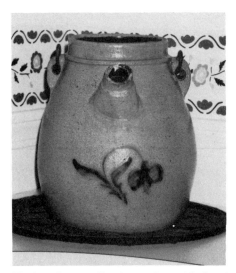

Unsigned one-gallon batter jug with floral decoration. $450-$550

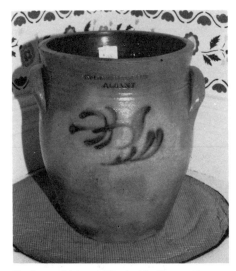

Early ovoid jar with simple flower decoration, New York State. $250-$400

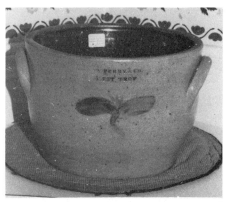

Rare milk pan with cobalt decoration, signed "S. Perry, West Troy" (New York). $450-$650

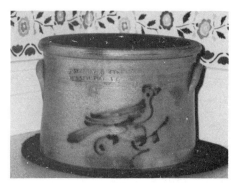

One-and-one-half-gallon crock signed "J. Norton and Co., Bennington, Vt." with cobalt bird decoration. $600 and up

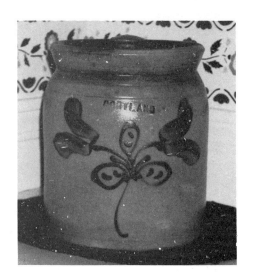

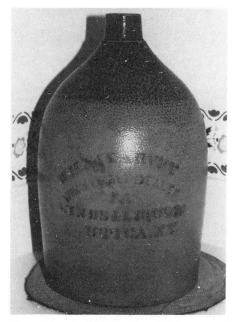

Stenciled advertising jug with unusual blued top. $275-$375

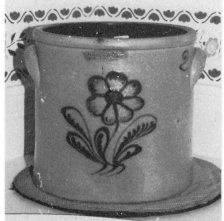

Crock signed "John Burger, Rochester" with detailed daisy. $400-$600

One-gallon preserve jar signed "Cortland" with brushed floral decoration. $375-$475

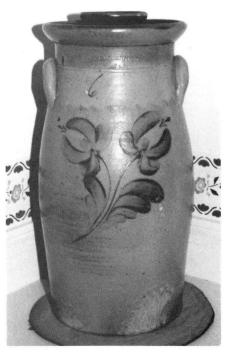

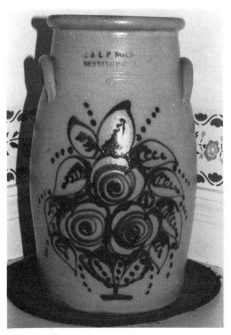

Six-gallon churn signed "T. Harrington, Lyons" (New York) with brushed flowers. $450–$550

Three-gallon churn signed "E. & L. P. Norton, Bennington, Vt." with very rare well-detailed basket of flowers. $4000 and up

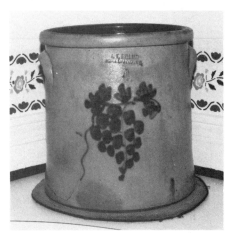

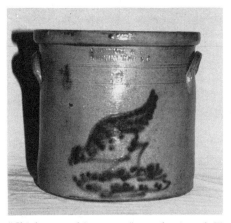

Four-gallon crock signed "A. K. Ballard, Burlington, Vt." with grapes. $700–$900

"Chicken pecking corn" crock signed "J. Norton & Co., Bennington, Vt." $1000 and up

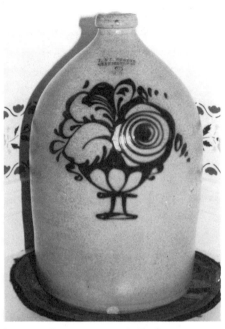

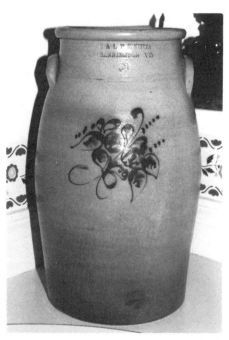

Three-gallon jug signed "J. & E. Norton, Bennington, Vt." with detailed basket of flowers decoration. **$1200–$1600**

Five-gallon churn signed "E. and L. P. Norton, Bennington, Vt." with dotted leaf spray. **$550–$650**

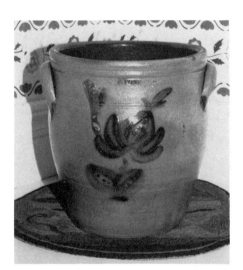

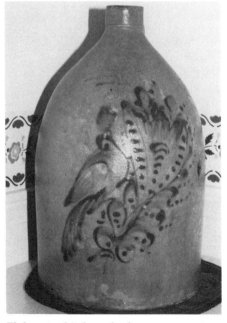

Floral decorated ovoid crock signed "Lyons," New York. **$275–$375**

Elaborate bird and plume on a store-marked jug. **$750–$950**

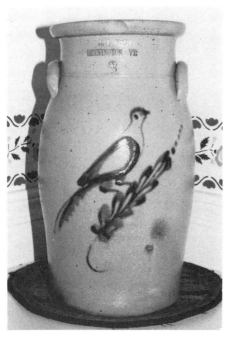

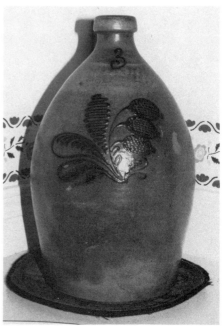

Three-gallon churn signed "E. and L. P. Norton, Bennington, Vt." with bird-on-plume decoration. **$850-$1000**

Three-gallon jug signed "Stezenmeyer and Goetzman, Rochester, N.Y.," with detailed dotted flower and rare maker's mark. **$1000-$1400**

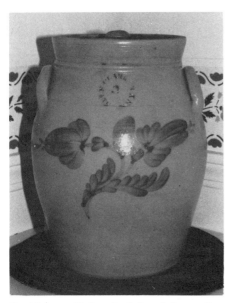

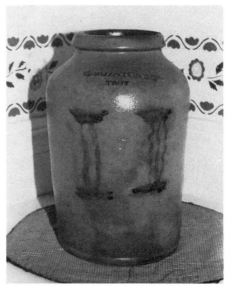

Ovoid jar with brushed floral decoration signed "Clark, Athens, N.Y." **$350-$450**

Early jar signed "C. Boynton & Co., Troy" with Roman-numeral-like decoration. **$650-$750**

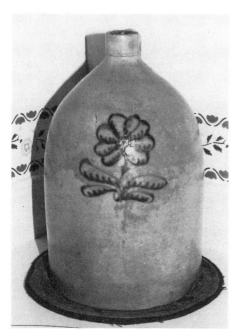

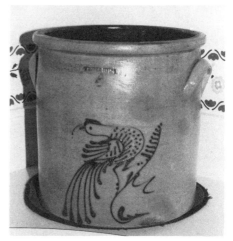

Four-gallon crock signed "Whites, Utica" with detailed running bird. **$650-$850**

*Flower-decorated jug signed "Burger, Rochester, N.Y." **$200-$400***

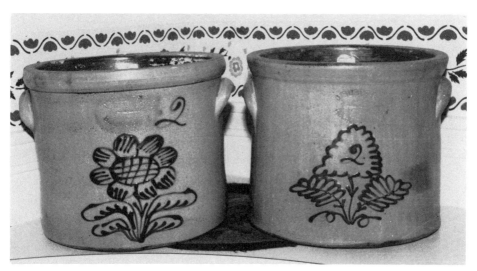

Two two-gallon crocks signed "Burger, Rochester, NY" with detailed decorations. **$200-$400** *each*

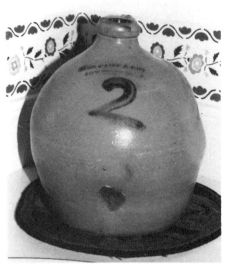

Early, almost ball-shaped ovoid jug signed "Jacob Caire & Co., Po'keepsie" with simple decoration. **$300 and up**

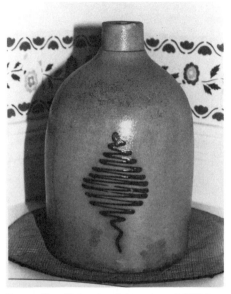

One-gallon "pine tree" jug signed "Whites, Utica, NY." **$150–$250**

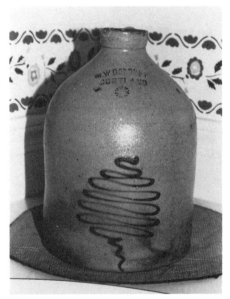

One-gallon jug signed "M. Woodruff, Cortland" with "pine tree" decoration. **$150–$250**

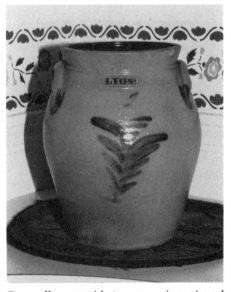

One-gallon ovoid preserve jar signed "Lyons." **$250–$375**

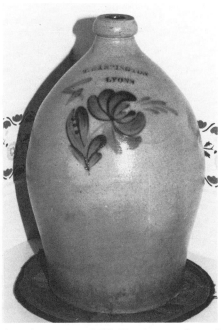

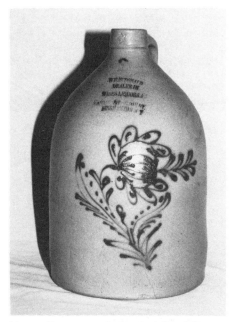

Two-gallon jug with detailed floral decoration and store mark. $400-$600

Ovoid jug signed "T. Harrington, Lyons" with large cobalt flower. $375-$475

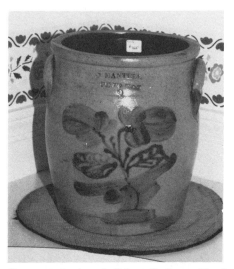

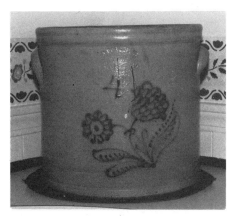

Four-gallon crock signed "J. Burger Jr., Rochester, N.Y." with double flower. $650-$750

Cream pot signed "Mantell, Penn Yan" (New York) with large basket of flowers. $875-$975

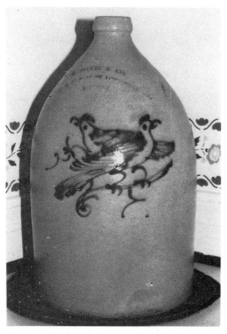

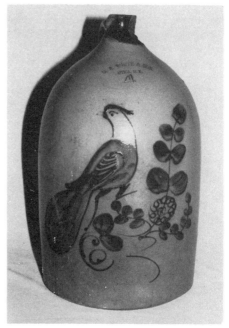

"Crossed" lovebirds on a Norton-made jug with a store or vendor's mark. **$1100–$1400**

Four-gallon jug signed "N. A. White and Son, Utica, N.Y." with large paddle-tail bird decoration, damage to the spout. **$500–$600** with damage

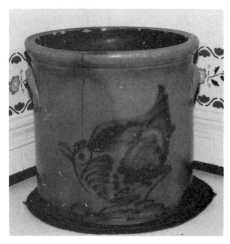

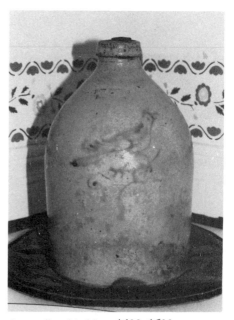

Unsigned crock with huge "chicken pecking corn" and through crack. **$575–$775** without crack

One-gallon bird jug. **$400–$600**

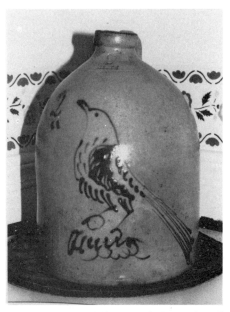

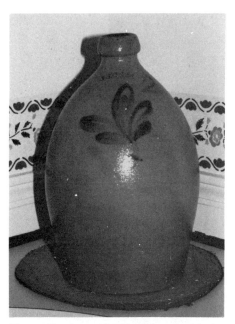

Two-gallon bird-decorated jug signed "Hart's" (Fulton, New York). $375-$475

Two-gallon jug with simple brushed design signed "Lyons" (New York). $150-$250

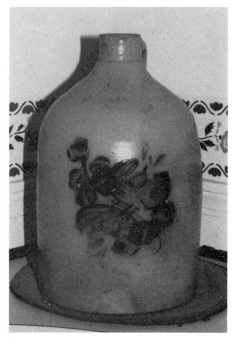

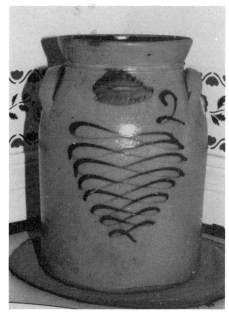

Two-gallon preserve jar with tornado design. $250-$350

Two-gallon jug signed "N. A. White and Son, Utica, N.Y." ·$275-$375

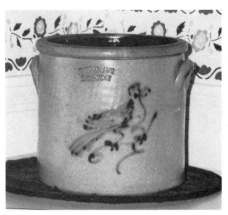

Two-gallon bird-decorated crock signed "E. W. Hale, Boston." $350-$450

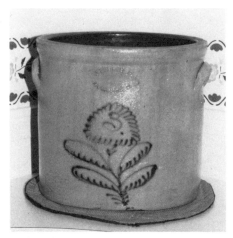

Three-gallon crock signed "J. Burger Jr., Rochester, N.Y." with floral decoration. $200-$300

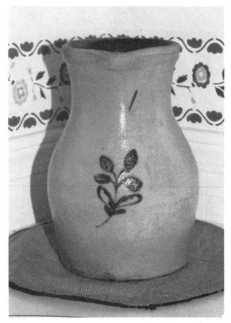

Unsigned one-gallon milk pitcher, probably from New York State. $450-$550

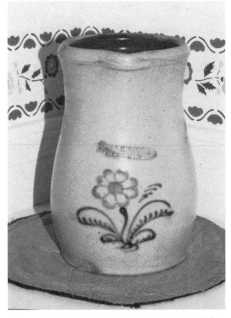

One-gallon milk pitcher signed "John Burger, Rochester." $900 and up

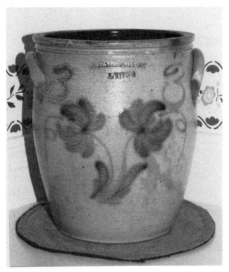

Three-gallon cream pot signed "T. Harrington, Lyons" (New York) with double flower. $450–$650

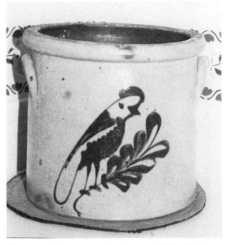

Three-gallon crock signed "F. Norton, Worcester, Mass." with parrot decoration. $600–$900

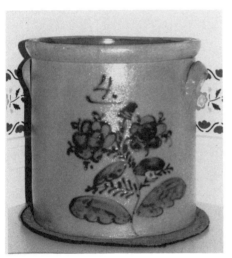

Four-gallon preserve jar with brushed floral decoration. $450–$650

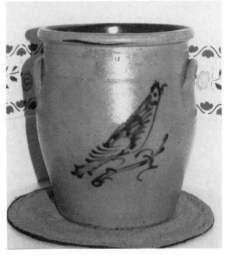

Cream pot with bird decoration signed "Norton, Bennington, Vt." $600–$700

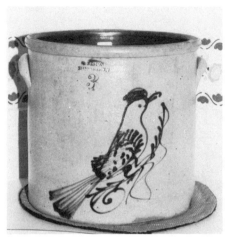

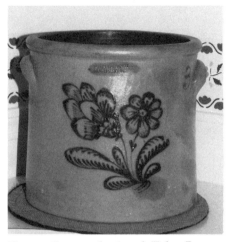

Three-gallon crock signed "De Weston, Ellenville, N.Y." with detailed bird. **$350-$450**

Three-gallon crock signed "John Burger, Rochester" with detailed double floral decoration. **$750 and up**

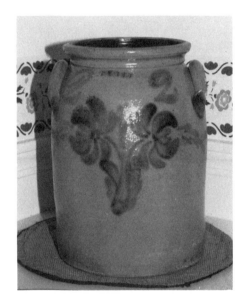

Two-gallon preserve jar signed "Lyons" (New York) with brushed floral decoration. **$300-$400**

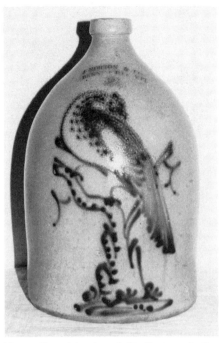

Two-gallon jug signed "J. Norton & Co., Bennington, Vt." with detailed peacock on a stump. **$2500-$4000**

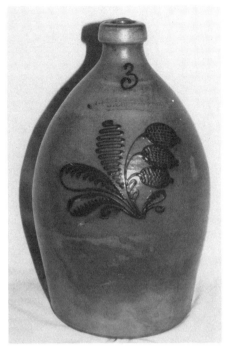

Three-gallon jug signed "F. Stetzenmeyer & Goetzman, Rochester, N.Y." with detailed and vivid floral decoration. **$1000-$1500**

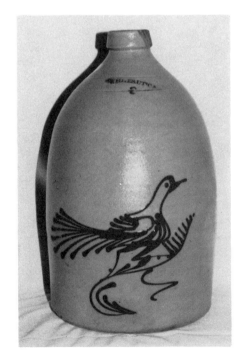

Four- and three-gallon crocks signed "Burger & Co., Rochester, N.Y." with typical fern wreath decoration with gallon size in middle. **$250-$550 each**

Three-gallon jug signed "Whites, Utica," (New York) with slip-decorated running bird. **$650-$850**

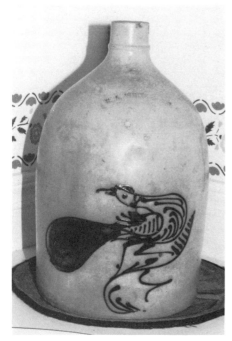

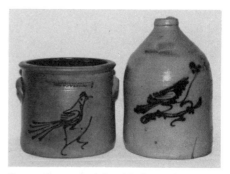

One-gallon straight-sided crock signed "Whites, Utica" with slip-decorated running bird, **$300–$450;** one-gallon jug signed "Whites, Utica" with slip-decorated bird on a branch, **$500–$700.**

Two-gallon jug signed "N.A. White & Son, Utica, N.Y." with paddle-tail running bird decoration. **$650–$850**

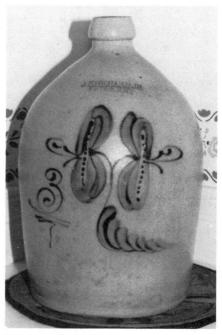

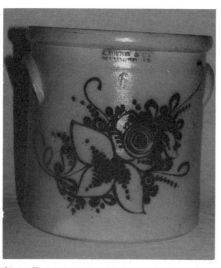

Three-gallon jug signed "J. Shepard, Jr., Geddes, N.Y." with stylized brush- and slip-decorated floral design. **$250–$500**

Six-gallon straight-sided crock signed "J. Norton & Co., Bennington, Vt." with vividly detailed slip-decorated floral spray. **$700–$900**

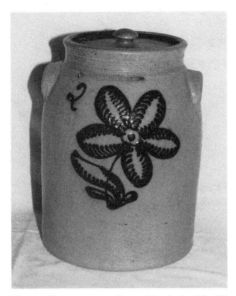

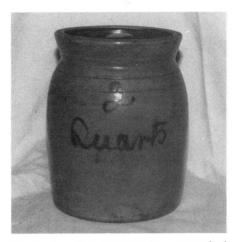

One-half gallon preserve jar, unmarked, attributed to Cortland, New York, with "2 quarts" in blue slip. $250–$450

Two-gallon preserve jar with desirable "F. Stetzenmeyer, Rochester, N.Y." signature and well-detailed flower decoration. $1000–$1500

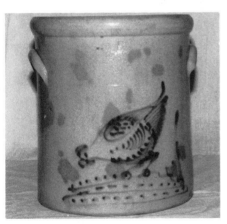

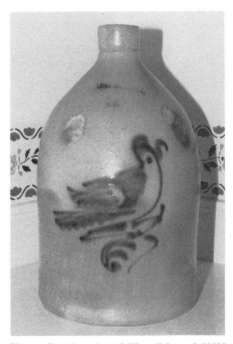

Five-gallon crock, unsigned, with rare "chicken-pecking-corn" design. $550–$950

Two-gallon jug signed "Fort Edward, N.Y." with slip-decorated "fat" bird decoration. $300–$600

105

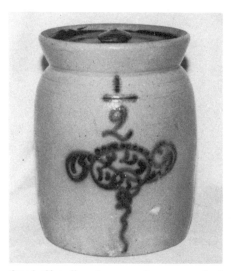

One-half gallon preserve jar, unmarked, attributed to Cortland, New York, in rare small size with slip decoration. $250-$450

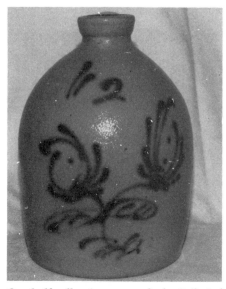

One-half gallon jug, unmarked, attributed to Cortland, New York, with slip-decorated double-floral design. $350-$650

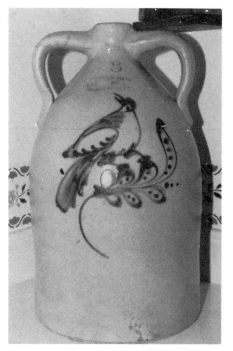

Rare double-handled five-gallon jug with Seneca Falls, New York, store or vendor's mark, decorated with a large bird on a branch. $900-$1400

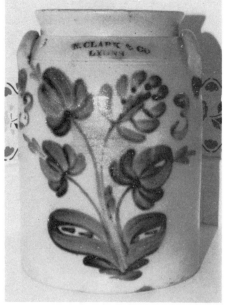

Three-gallon preserve jar signed "N. Clark & Co., Lyons" (New York) with large brushed floral design and double "3" capacity marks. $750-$1250

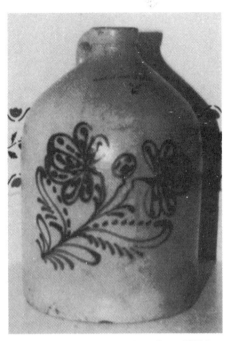

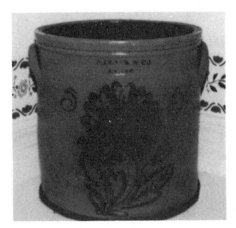

Five-gallon straight-sided crock signed "N. Clark & Co., Lyons" with an extremely well-detailed large floral decoration. **$1500-$2500**

Two-gallon jug signed "Whites, Binghamton" with slip-decorated double floral design. **$250-$500**

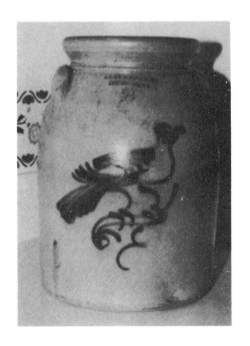

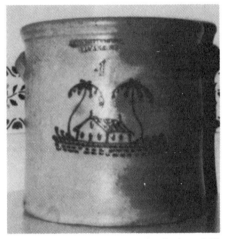

Four-gallon straight-sided crock signed "A. O. Whitmore, Havana, N.Y." with very rare decoration of a house with double palm trees. **$3500-$4500**

Two-gallon preserve jar signed "J. A. & C. W. Underwood, Fort Edward, New York" with slip-decorated bird on a branch. **$450-$650**

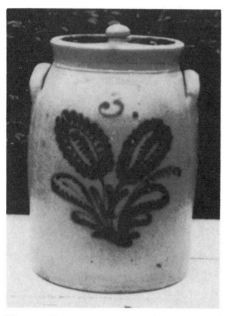

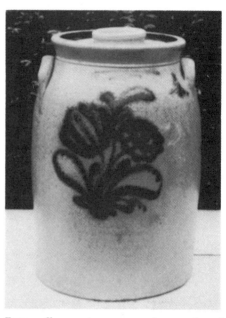

Three-gallon preserve jar signed "Harrington & Burger, Rochester" with slip-decorated double floral design. **$1200–$1500**

Four-gallon preserve jar signed "Harrington & Burger, Rochester" with slip-decorated double floral decoration. **$1500**

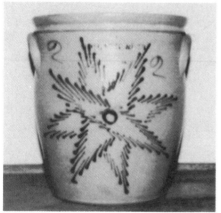

Two-gallon cream pot signed "Clark & Co., Lyons" with rare slip-decorated starburst design. **$2500**

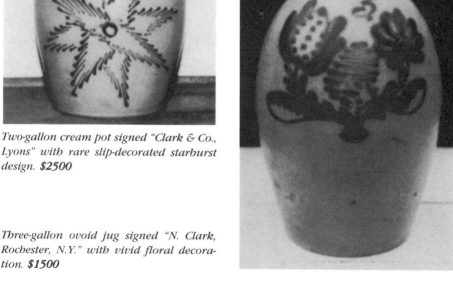

Three-gallon ovoid jug signed "N. Clark, Rochester, N.Y." with vivid floral decoration. **$1500**

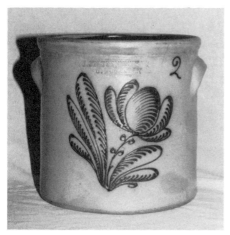

Two-gallon straight-sided crock signed "F. Stetzenmeyer & G. Goetzman, Rochester, N.Y." with large floral decoration. $900

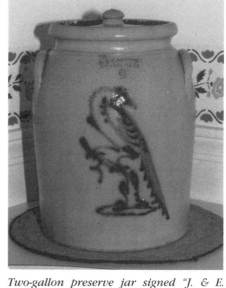

Two-gallon preserve jar signed "J. & E. Norton, Bennington, Vt." with peacock on stump. $800–$1200

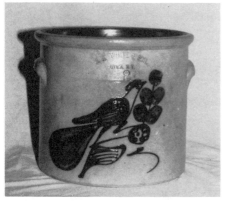

Two-gallon straight-sided crock signed "N. A. White & Son, Utica, N.Y." with paddle-tail bird decoration. $650

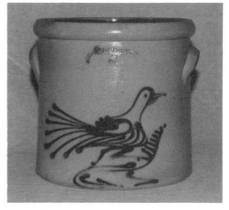

Two-gallon straight-sided crock signed "Whites, Utica" with slip-decorated running bird. $650–$950

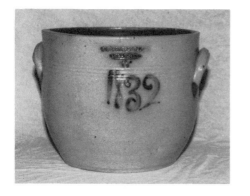

Three-gallon ovoid crock signed "Clark & Fox, Athens" (New York) with unusual "1832" date decoration. $450–$950

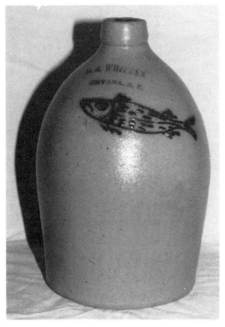

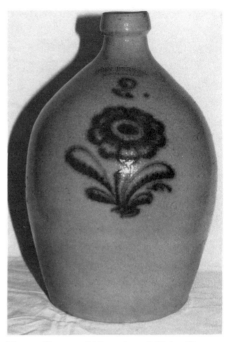

One-gallon jug signed "H. M. Whitman, Havana, N.Y." with rare slip-decorated fish. *$3500–$4500*

Two-gallon ovoid jug signed "John Burger, Rochester" with large slip-decorated daisy. *$600–$900*

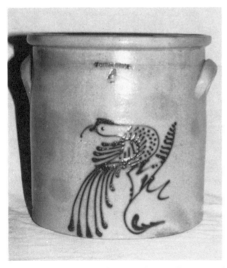

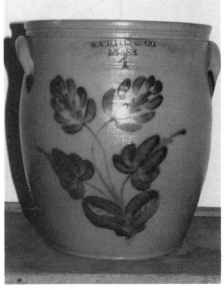

Four-gallon straight-sided crock signed "Whites, Utica" with a rare slip-decorated running bird looking backward. *$650–$950*

Four-gallon cream pot signed "N. Clark & Co., Lyons" with a four-bud brushed floral decoration. *$750–$1250*

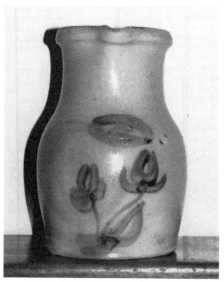

Two-gallon jug signed "J. Burger Jr., Rochester, N.Y." with wreath decoration and gallon size in center, $250–$550; two-gallon preserve jar signed "Penn Yan" with unusual slip-decorated framed floral design, $550–$750.

One-gallon water pitcher signed "Burger & Lang, Rochester, N.Y." with double brushed floral decoration. $950–$1650

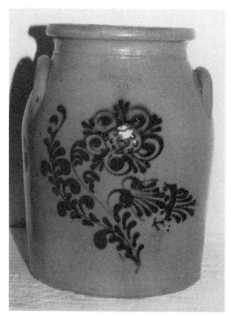

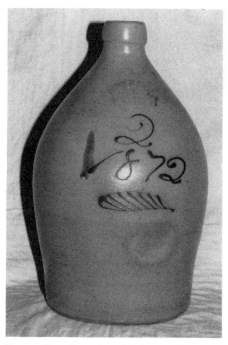

Two-gallon jug signed "Burger & Lang, Rochester, N.Y." and dated "1872." $450–$950

Two-gallon preserve jar signed "J. E. & E. Norton, Bennington, Vt." with vividly detailed geometric floral decoration. $650–$950

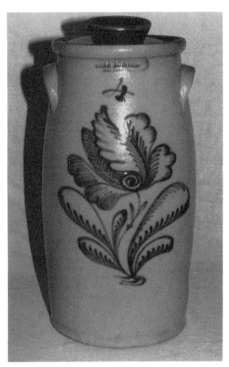

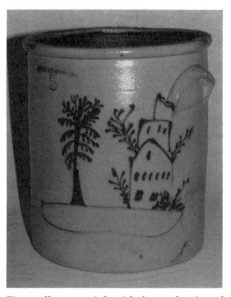

Five-gallon straight-sided crock signed "White & Co., Binghamton" with unusual folksy house and tree—rare decorations. $3500

Four-gallon churn signed "John Burger, Rochester" with rare huge and detailed floral decoration. $1800

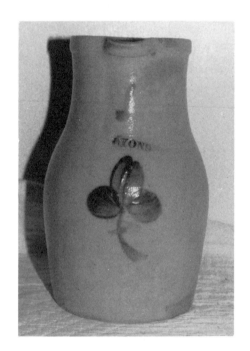

One-gallon milk or water pitcher signed "Lyons" with simple brushed clover flower design. $750–$1450

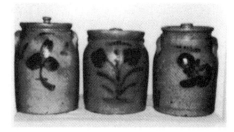

Three one-gallon preserve jars, signed "Lyons," "Cortland," and "Penn Yan." All have brushed floral decorations. *$250–$550 each*

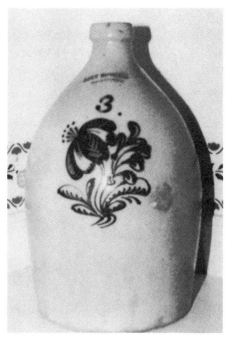

Three-gallon jug signed "John Burger, Rochester," (New York) with large floral decoration. *$650–$1150*

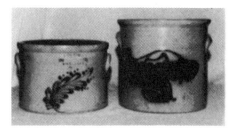

Two-gallon rare cake crock with slip-decorated plume signed "New York Stoneware Company, Fort Edward, N.Y.," *$350–$450;* three-gallon straight-sided crock signed "N. A. White & Son, Utica, N.Y." with bright blue orchid design, *$250–$500*

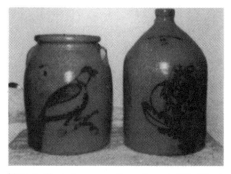

Two-gallon preserve jar signed "N. Clark Jr., Athens, N.Y." with large fat bird decoration, *$550–$850;* two-gallon jug signed "N. White & Co., Binghamton" with poppy design in blue slip, *$250–$500.*

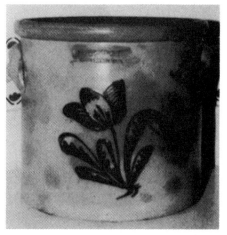

Three-gallon straight-sided crock signed "Burger & Co., Rochester, N.Y." with slip-decorated floral design. *$300–$600*

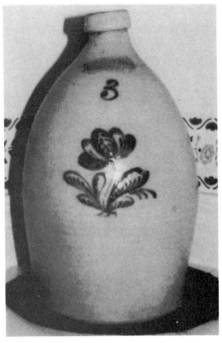

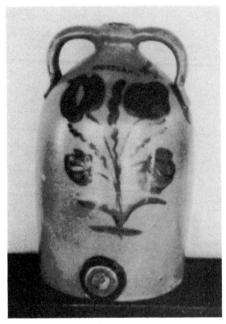

Three-gallon jug signed "John Burger, Rochester" with slip-decorated floral design. *$300–$600*

Four-gallon double-handled cooler signed "Cortland" with brush-decorated flower. *$1150–$1450*

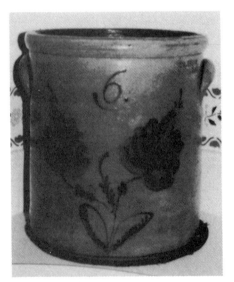

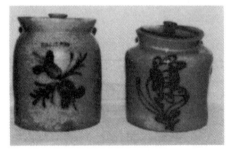

One-half-gallon preserve jar with rare "Cortland" signature and slip- and brush-decorated flower, *$250–$550;* one-half-gallon unsigned preserve jar attributed to Whites, Binghamton, New York, decorated in blue slip, *$250–$550.*

Six-gallon straight-sided crock signed "C. W. Braun, Buffalo, N.Y." with brush- and slip-decorated double flower. *$450–$750*

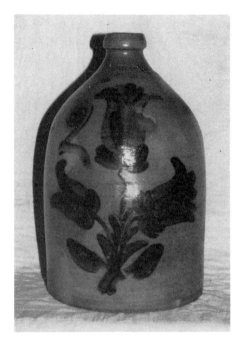

Two-gallon jug signed "Geddes, N.Y." with top to bottom brushed flower decoration. *$450–$750*

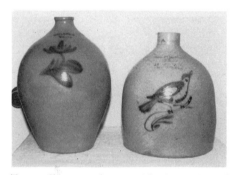

Two-gallon early ovoid jug signed "Seymour, Troy," (New York) with early decoration of a simple brushed flower, *$300–$550;* two-gallon beehive-shaped jug from Fort Edward, New York, with slip-trailed blue bird, *$450–$650.*

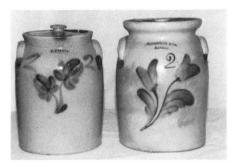

Two 2-gallon preserve jars from Lyons, New York, with brushed flower decoration. *$250–$450 each*

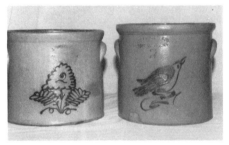

Two-gallon straight-sided crock signed "J. Burger Jr., Rochester, N.Y." with slip-decorated fern, *$250–$550;* two-gallon straight-sided crock signed "Ottman Bros., Ft. Edward, N.Y." with fat bird decoration, *$400–$650.*

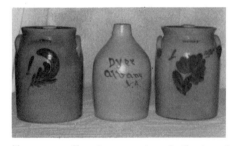

Two one-gallon preserve jars both signed "Lyons" with brushed flower designs, *$250–$550 each;* with a one-half gallon unsigned advertising jug with the store mark "Dyer, Albany, N.Y.," *$150–$250.*

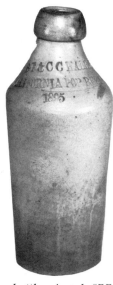

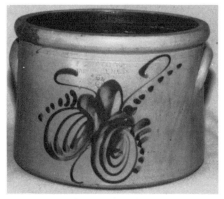

Three-gallon straight-sided crock signed "F. B. Norton & Co., Worcester, Mass.," in need of repair to a crack. **$150-$160**

Stoneware bottle signed "BF and CC Haley/California Pop Beer 1895," 9½" tall. **$65**

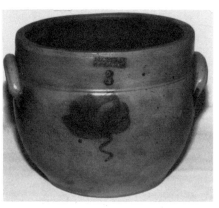

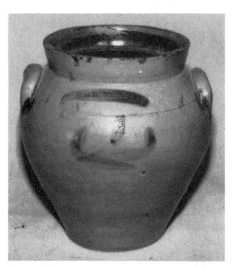

One-gallon ovoid jar, signed "N. White, Utica." **$150-$160**

Three-gallon wide-mouthed jar signed "N. C. Bell/Kingston," 3". **$500-$550**

Stoneware barrel with "USA" stamped on the bottom, unglazed and molded, 6½" tall, **$20-$30**; stoneware barrel, unmarked, 7" tall, **$20-$30**.

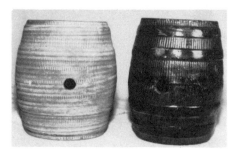

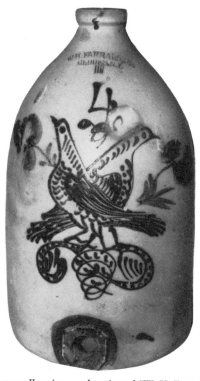

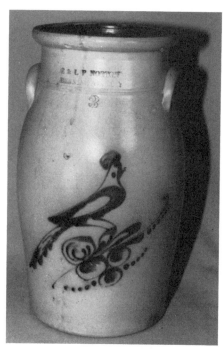

Four-gallon jug-cooler signed "W. H. Farrar & Co., Geddes, N.Y." **$4400-$4600**

Three-gallon churn signed "E. and L. P. Norton, Bennington, Vt." **$750-$825**

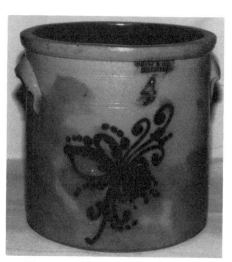

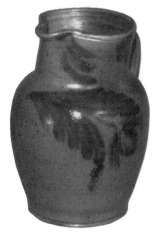

Four-gallon straight-sided crock signed "C. Hart and Soṅ, Sherburne" (New York). **$250-$350**

One-gallon unmarked Pennsylvania pitcher with brushed decoration. **$700-$750**

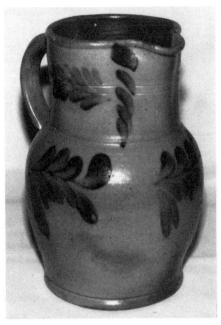

One-gallon Pennsylvania pitcher, un-marked, 11″ tall. **$700-$750**

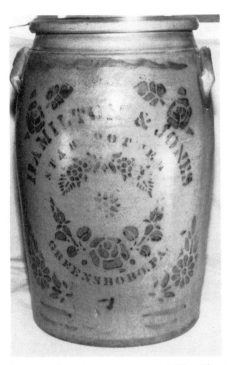

Seven-gallon storage jar signed "Hamilton and Jones, Star Potter, Greensboro, Pa." **$800-$1000**

Three-gallon jug signed "Geddes, N.Y." with slip-trailed blossoms. **$175-$200**

Two-quart wax sealer preserve jar, 9″ tall, c. 1870. **$230-$250**

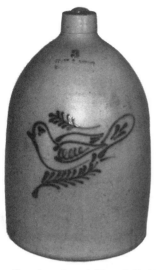

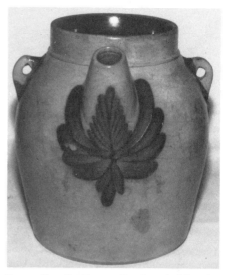

Three-gallon jug signed "Frank B. Norton, Worcester, Mass." 15″ tall, c. 1879. **$750-$800**

One-gallon batter pail, signed "Cowden and Wilcox, Harrisburg," 9″ tall, c. 1872. **$1900-$2100**

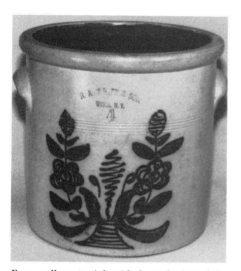

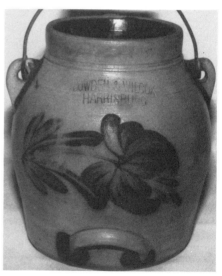

Four-gallon straight-sided crock signed "N. A. White and Son, Utica, N.Y." with urn or compote holding two flowers, 12″ tall, c. 1884. **$650-$700**

Another angle of the one-gallon batter pail.

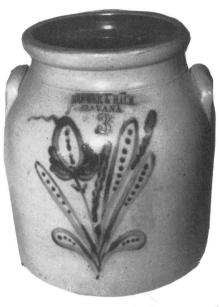

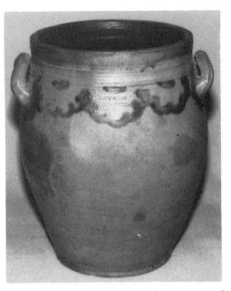

Three-gallon jar signed "Bremer and Halm, Havana, N.Y." **$585-$615**

Three-gallon wide-mouthed jar signed "C. Crolius/Manufacturer/Manhattan Wells/New York." **$2000-$3000**

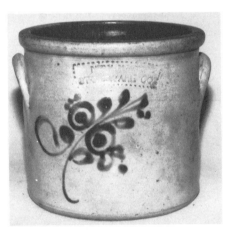

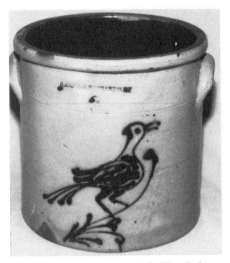

One-gallon crock signed "New York Stoneware Co." with floral cobalt decoration. **$150-$200**

Three-gallon crock signed "W. Roberts, Binghamton, N.Y." **$700-$750**

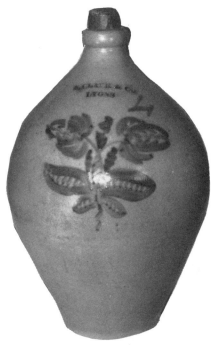

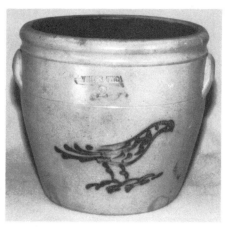

Two-gallon jar signed "Whites, Utica, N.Y." with slip-trailed chicken or rooster. $300-$400

Four-gallon ovoid jug signed "N. Clark and Co., Lyons, N.Y." $700-$800

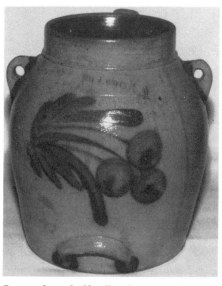

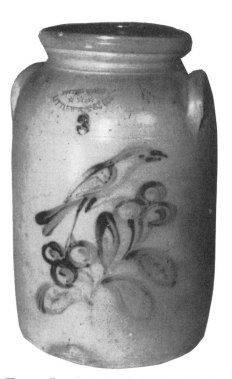

One-and-one-half-gallon batter pail signed "Cowden and Wilcox" with cobalt leaves and berries. $2800-$3000

Three-gallon jar signed "Pottery Works, N.Y.," c. 1866. $1000-$2000

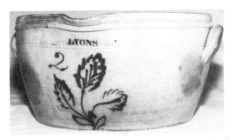

Two-gallon milk pan signed "Lyons," 6½" tall, c. 1860. **$1700-$1800**

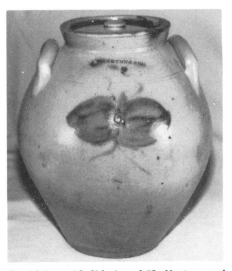

Ovoid jar with lid signed "L. Norton and Son," c. 1835, with cobalt moth or butterfly. **$1400-$1600**

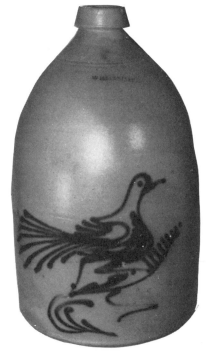

Four-gallon jug signed "Whites Utica," 18" tall, with running bird. **$650-$850**

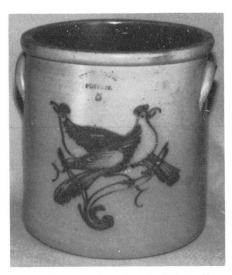

Five-gallon crock signed "West Troy Pottery," 13" tall, c. 1879. **$800-$1200**

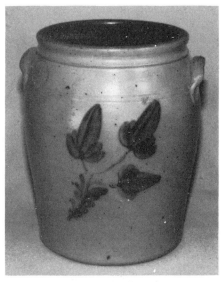

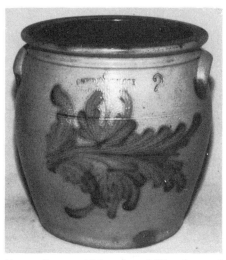

Three-gallon jar signed "Leathers & Brother, Howard, Pa.," 12″ tall. $750–$800

Two-gallon ovoid jar signed "Cowden and Wilcox, Harrisburg, Pa.," 10″ tall, c. 1869. $600–$700

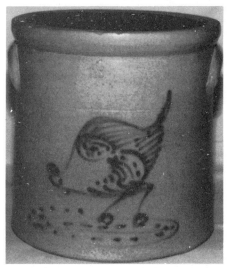

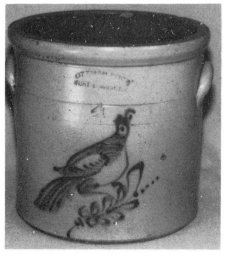

Four-gallon crock, unmarked, 12″ tall, with minor restoration and "chicken-pecking-corn" decoration. $500–$600

Four-gallon crock signed "Ottman Bros, Fort Edward, N.Y.," 12″ tall, c. 1872. $475–$500

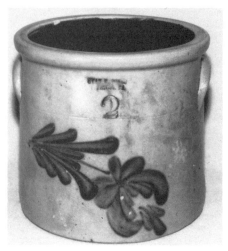

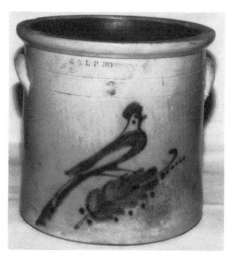

Two-gallon crock signed "Evan R. Jones, Pittston, Pa.," 9½" tall, c. 1879, with some glaze flaking. **$140-$175**

Three-gallon crock signed "E. and L. P. Norton, Bennington, Vt.," 10½" tall, c. 1871, with some rim chips. **$375-$425**

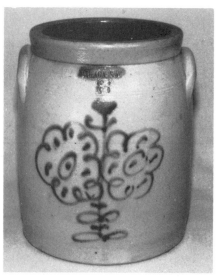

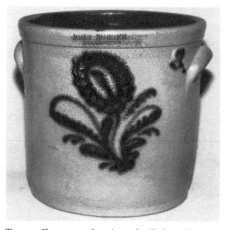

Two-gallon crock signed "John Burger, Rochester," c. 1861. **$600-$900**

Three-gallon jar signed "Ithaca, N.Y.," 12½" tall, c. 1886, with double flower. **$300-$375**

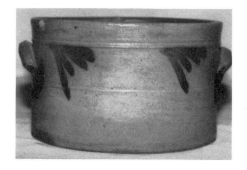

One-gallon Pennsylvania butter crock, unmarked, no lid, 5" tall, c. 1860. **$200-$225**

124

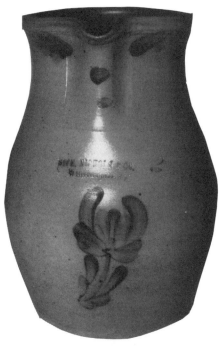

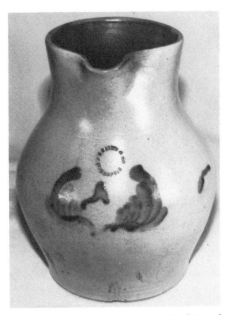

Two-gallon Pennsylvania pitcher signed "Sipe, Nichols, & Co., Williamsport, Pa.," 13" tall, c. 1872. **$1100–$1300**

Two-gallon pitcher signed "J. B. Caire & Co." 12" tall, c. 1842. **$700–$900**

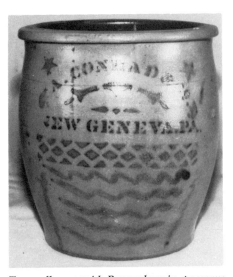

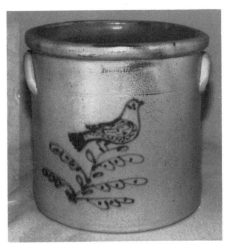

Three-gallon crock signed "Evan R. Jones, Pittston, Pa.," 11" tall, c. 1870. **$1300–$1800**

Two-gallon ovoid Pennsylvania preserve jar signed "A. Conrad & Co., New Geneva, Pa.," 10" tall, c. 1872, with minor restoration. **$250–$350**

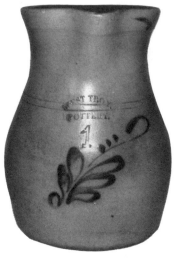

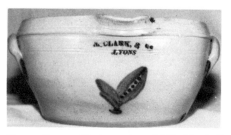

One-gallon milk pan signed "N. Clark & Co., Lyons," 5½" tall × 10" wide, c. 1837. **$1800-$1900**

One-gallon pitcher signed "West Troy Pottery," c. 1865. **$700-$900**

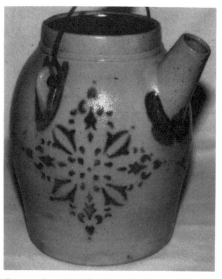

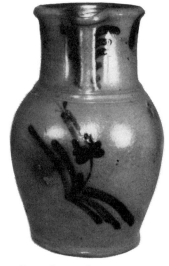

One-gallon Pennsylvania pitcher, unmarked, 12" tall, c. 1860. **$625-$700**

One-and-one-half-gallon batter pail with stenciled decoration, F. H. Cowden, Harrisburg, Pennsylvania, 11" tall. **$1500-$1600**

Rare bell-shaped stoneware bank, unmarked, c. 1850. **$200-$250**

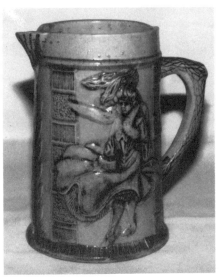

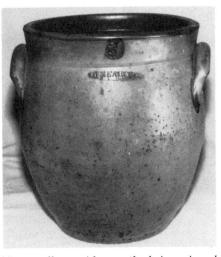

Three-gallon wide-mouthed jar signed "M. Meade & Co.," 12" tall. **$225-$250**

One-half gallon unmarked pitcher, probably made by the Robinson Clay Pottery Co. of Akron, Ohio, 8½" tall, c. 1910. **$200-$250**

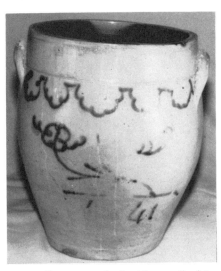

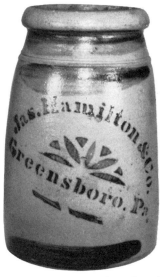

Pennsylvania preserve jar signed "Jas. Hamilton & Co., Greensboro, Pa." with stenciled fan and three broad stripes. **$275-$325**

Four-gallon unmarked wide-mouthed jar, 13½" tall, c. 1841. **$375-$450**

Stoneware coffeepot, of approximately one-quart capacity, Bodine Pottery Co., Zanesville, Ohio, with tinware straps, handle, spout, cover, and wire bail handle all original and intact, 8½" tall, c. 1880. **$750–$825**

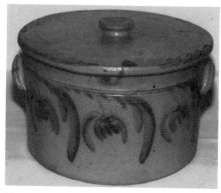

Three-gallon unmarked Pennsylvania butter crock with lid, 7" tall, c. 1860. **$750–$850**

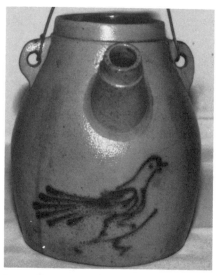

One-gallon unmarked batter pail, probably Whites Pottery, Utica, New York, 9½" tall, c. 1860. **$1500–$1600**

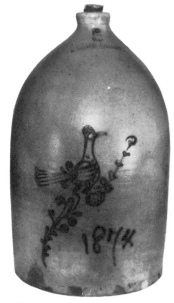

Five-gallon jug signed "W. Roberts, Binghamton, N.Y.," some base chips, 20" tall, c. 1874. **$1000–$1500**

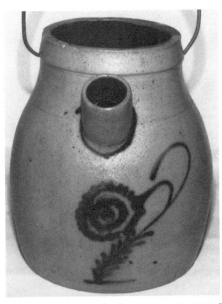

One-gallon unmarked batter pail, 10½″ tall, c. 1875. **$400–$460**

Stoneware bottle, one pint, unmarked, 8½″ tall, c. 1860. **$80–$150**

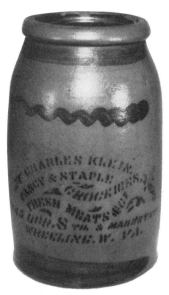

Three-quart Pennsylvania preserve jar, unmarked vendor's jar from Wheeling West Virginia, 10″ tall, c. 1865. **$250–$300**

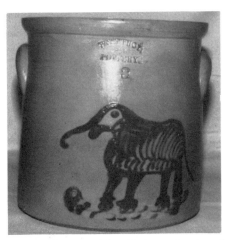

Three-gallon straight-sided crock signed "West Troy, N.Y., Pottery," extensively restored, 11″ tall, c. 1879. **$2000–$3000**

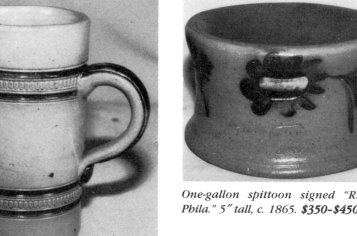

One-gallon spittoon signed "R. C. R., Phila." 5″ tall, c. 1865. **$350-$450**

Mug made by Whites Pottery, Utica, New York, 5½″ tall, c. 1895. **$40-$50**

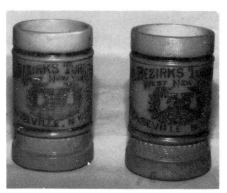

Mug made by Central New York Pottery, Utica, New York, 5″ tall, c. 1894, **$125-$175**; mug made by Central New York Pottery, with restored lip chip, 5″ tall, **$125-$135**.

Two-gallon jar made by O. L. and A. K. Ballard, Burlington, Vermont, 11″ tall, c. 1862. **$100-$200**

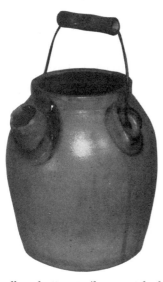

Unmarked flask, 8½" tall, c. 1895. **$115-$140**

One-gallon batter pail, unmarked with chips around spout and rim, 9" tall, c. 1865. **$115-$130**

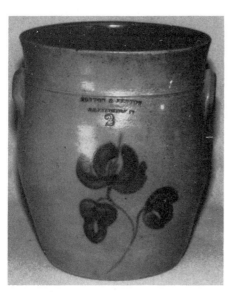

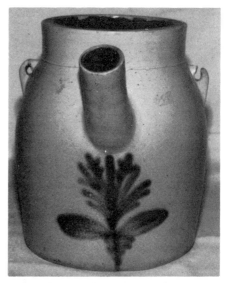

Five-gallon crock made by Whites, Utica, New York, 13" tall, c. 1862. **$550-$600**

Two-gallon jar signed "Norton & Fenton, Bennington, Vt.," 11" tall, c. 1844. **$550-$600**

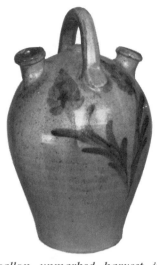

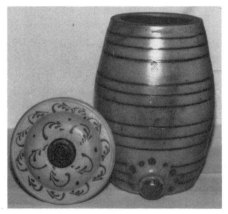

Three-gallon unmarked barrel cooler, 14½" tall, c. 1867. $450-$550

One-gallon unmarked harvest jug of questionable age, 15" tall. $175-$200

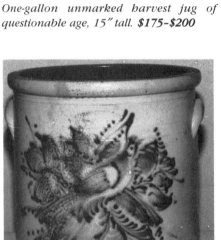

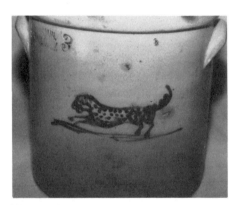

Three-gallon straight-sided crock signed "C. W. Braun, Buffalo, N.Y." with "leaping leopard" cobalt decoration, 10½" tall, c. 1870. $1500-$2000

Six-gallon straight-sided crock signed "Fort Edward Stoneware, Co.," c. 1885. This is a "puzzle" crock with six birds hidden in the decoration. $2100-$2400

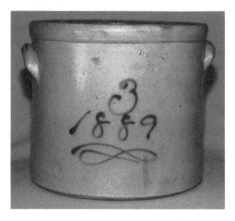

Three-gallon straight-sided crock signed "J. Burger Jr., Rochester, N.Y." and "1889" with minor rim chips and some glaze flaking, 10" tall. $300-$400

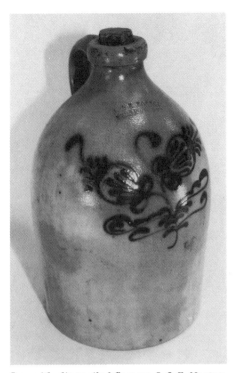

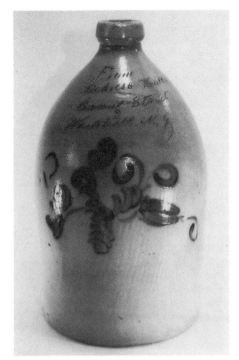

Jug with slip-trailed flowers, J. & E. Norton, Bennington, Vermont. **$400-$450**

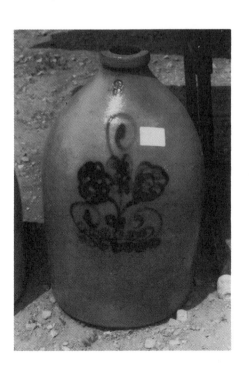

Unusual incised two-gallon vendor's jug from Whitehall, New York, with brushed decoration. **$400-$500**

Three-gallon jug with cobalt pot of flowers. **$325-$350**

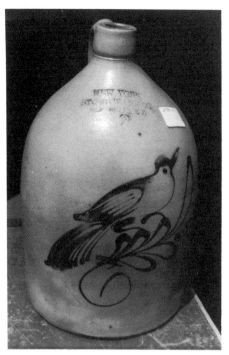

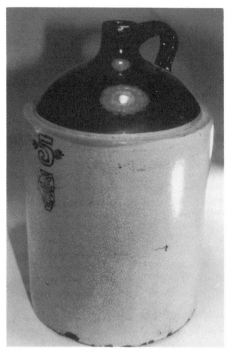

New York Stoneware Company two-gallon jug with elaborate brushed cobalt bird. $550–$650

Five gallon "platform" jug, molded with Albany slip and Bristol glaze. $45–$55

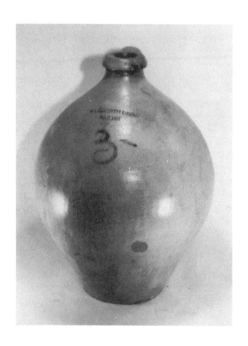

Three-gallon ovoid jug from Albany, New York. $150–$175

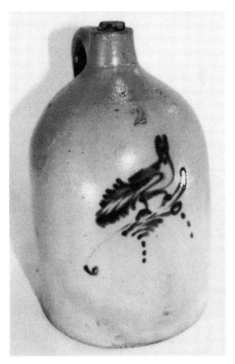

Two-gallon New York State "bird" jug.
$335-$375

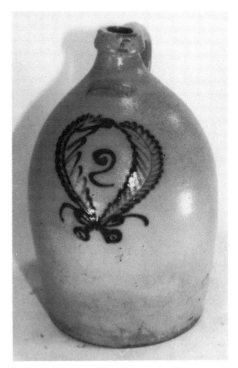

Two-gallon jug with cobalt wreath.
$250-$325

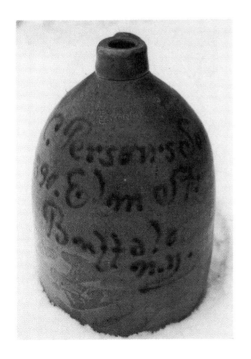

Vendor's jug with brushed label, made by Cooperative Pottery, Lyons, New York.
$150-$175

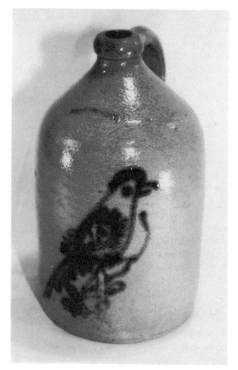

Unmarked and undecorated one-gallon jug, Bristol glaze. *$35–$50*

Two-gallon New York State "bird" jug. *$375–$425*

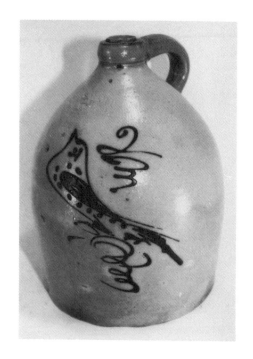

Two-gallon jug with slip-trailed bird design. *$500–$600*

136

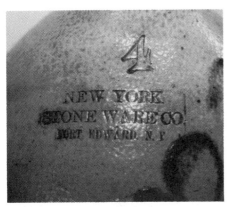

Impressed "4" capacity mark and "New York Stoneware Co. Fort Edward, N.Y." This pottery did business from approximately 1861 to 1891 under the name New York Stoneware Co. It is possible to get an approximate date for the operation of a particular pottery by checking the name with a reference source. Webster's Decorated Stoneware of North America (Charles E. Tuttle Co.) provides collectors with a wealth of data about the periods of operation.

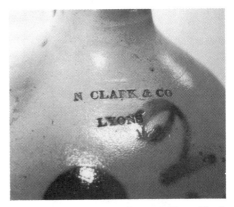

N. Clark and Co., Lyons, New York, 1825-1852.

John Burger, Rochester, New York, 1860s.

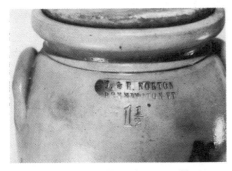

J. & E. Norton, Bennington, Vermont, 1850-1861. Between 1839 and 1894 there were various combinations of Nortons and Fentons in the stoneware factory at Bennington, Vermont. The pottery works at Bennington are probably the most documented and researched of all stoneware operations.

L. E. Holdridge is the name of the businessman or vendor who had his name impressed on jugs that were made to hold his product.

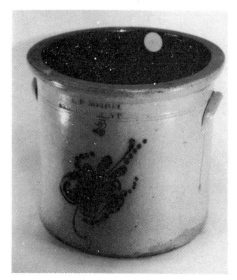

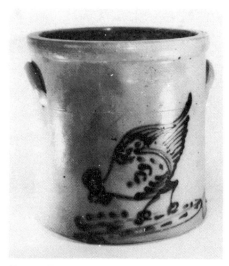

Two-gallon unmarked chicken-pecking-corn crock. $800-$1000

Two-gallon Norton crock with slip-trailed floral spray. $500-$650

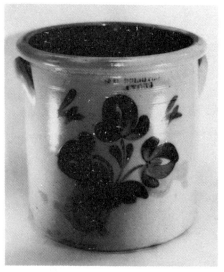

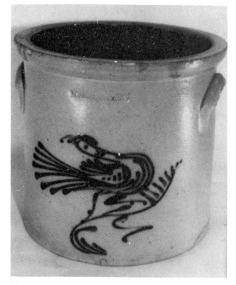

Decorated four-gallon crock with brushed cobalt flower, Lyons, New York. $400-$500

Two-gallon crock with slip-trailed bird. $700-$900

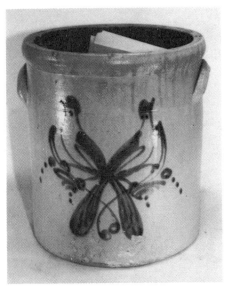

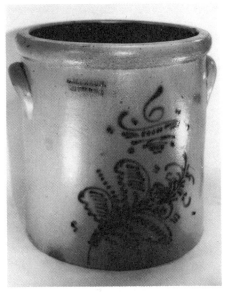

Unmarked five-gallon crock with double birds on a branch. **$1200-$1500**

Braun Pottery, Buffalo, New York, six-gallon crock with slip-trailed floral decoration. **$300-$400**

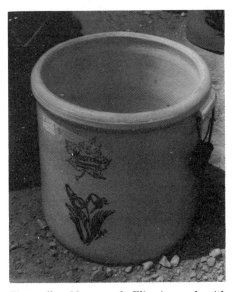

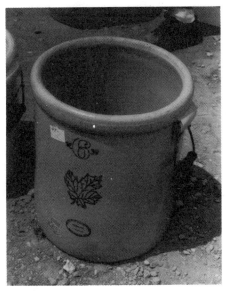

Five-gallon Monmouth, Illinois, crock with stenciled decoration. **$65-$75**

Six-gallon crock, stenciled decoration. **$50-$75**

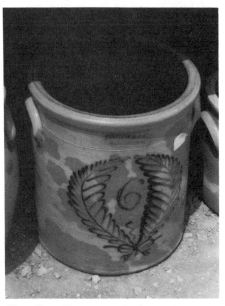

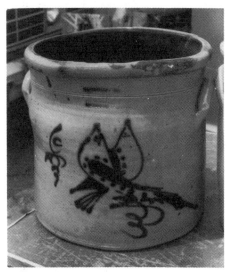

Crock, S. Hart, Fulton, New York. *$700-$900*

Six-gallon Burger and Company crock, Rochester, New York. *$425-$500*

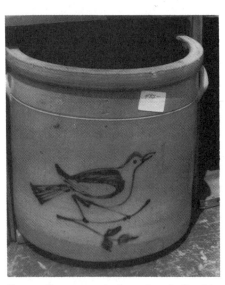

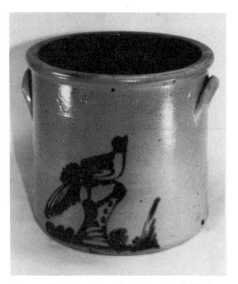

Four-gallon crock with deep cobalt bird on a stump. *$600-$725*

Four-gallon unmarked crock, cobalt robin. *$200-$300*

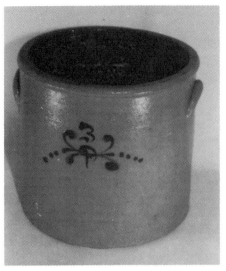

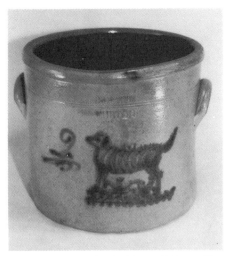

Two-gallon crock, S. Hart, Fulton, New York, with slip-trailed dog. $2000-$3000

Three-gallon crock with simple slip-trailed swirls. $100-$135

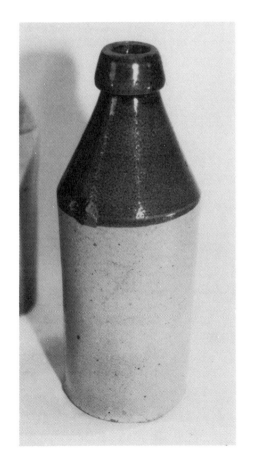

Unmarked crock dated "1895"; damage to rim and front dramatically lowers value: $200-$225 as is, $375-$425 if perfect.

Unmarked stoneware bottle dipped in blue cobalt. $50-$60

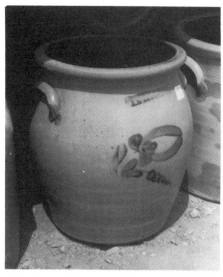

Ovoid jar with brushed flower. $275-$325

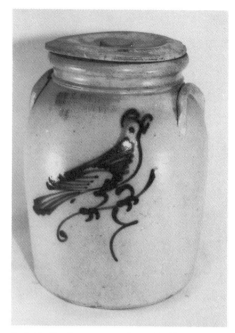

J. & E. Norton one-and-one-half-gallon jar with slip-trailed bird. $600-$700

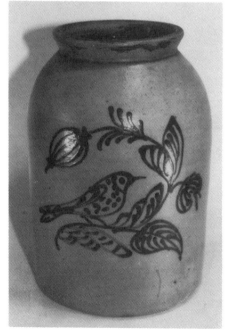

Unmarked jar with elaborate slip-trailed bird and leaf in deep cobalt, probably Edmonds. $400-$600

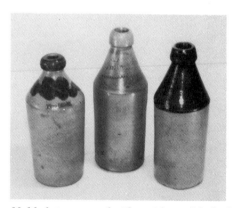

Molded stoneware bottles with any kind of decoration or mark are fairly difficult to find. These molded bottles date from the second half of the nineteenth century. $60 and up

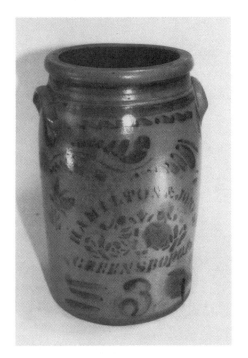

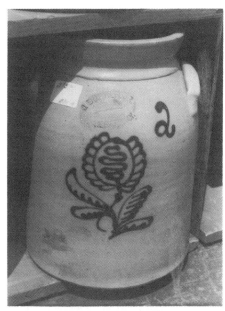

Burger two-gallon jar from Rochester, New York, slip-trailed flower. $350-$450

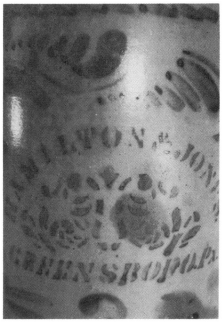

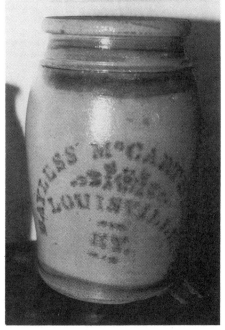

Three-gallon Hamilton and Jones, Greensboro, Pennsylvania, jar with stenciled and brushed decoration. $500-$575

Canning jar with stenciled label and brushed decoration at top and bottom, from Louisville, Kentucky. $200-$225

Stoneware jar from North Carolina, early nineteenth century. $250-$300

Unmarked stoneware fruit jar from the late nineteenth century with world-class glaze flaking. $15-$20

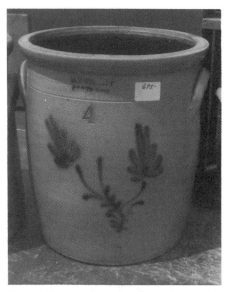

Simple Pennsylvania redware jar, Albany slip decoration. $70-$80

Four-gallon jar from Cortland, New York, with cobalt flowers. $600-$700

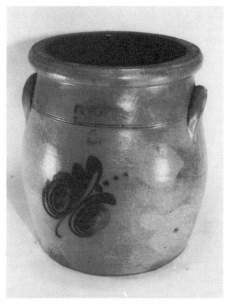

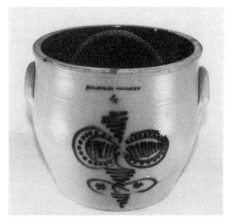

Athens, New York, four-gallon jar with slip-trailed abstract floral decoration. $300–$400

Three-gallon jar with cobalt floral spray from the Norton Pottery, Worcester, Massachusetts. $200–$300

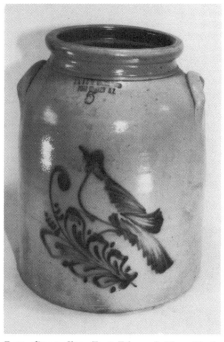

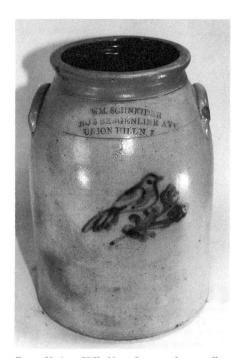

Rare Union Hill, New Jersey, three-gallon jar with a delicate bird and branch decoration. $600–$700

Rare five-gallon Fort Edward, New York, stoneware jar with elaborate bird and floral spray. $500–$700

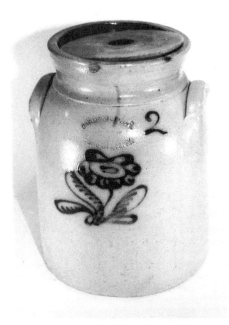

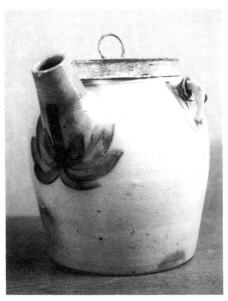

Decorated stoneware batter jar with bale handle and pouring spout, probably from Pennsylvania. $850-$1000

Two-gallon New York State jar with slip-trailed cobalt flower. $375-$425

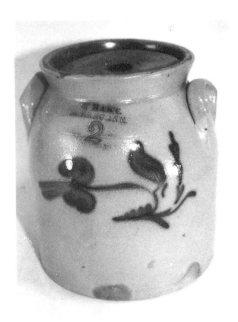

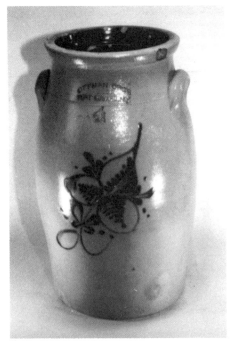

Two-gallon stoneware jar from the Hart Pottery decorated with a bird on a flower stem. $200-$300

Four-gallon churn with floral spray decoration, Ottman Bros., Fort Edward, New York. $600-$900

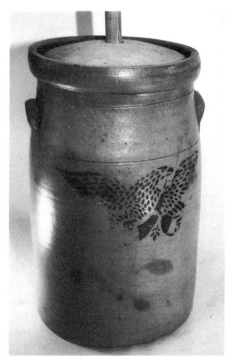

Pennsylvania churn with stenciled eagle.
$900–$1200

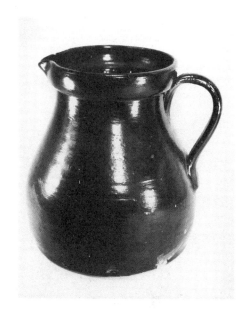

Two-gallon Monmouth, Illinois, stoneware churn with stenciled decoration.
$225–$275

Stoneware pitcher, unmarked, Albany slip.
$100–$125

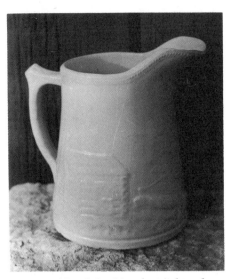

Reverse side of the Lincoln pitcher showing the log cabin in which Lincoln was born.

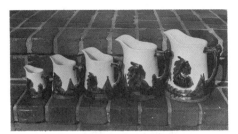

Set of five Sleepy Eye pitchers from the Monmouth Pottery. *$1800-$2400*

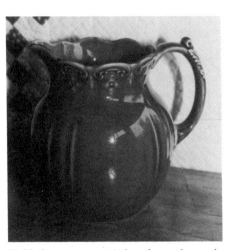

Molded stoneware pitcher from the early twentieth century. *$75-$85*

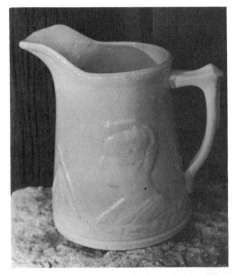

Molded Abe Lincoln pitcher, White Hall Pottery, White Hall, Illinois. *$300-$350*

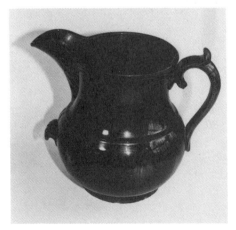

Rockingham pitcher, commonly referred to as Bennington-type, late nineteenth century. *$225-$275*

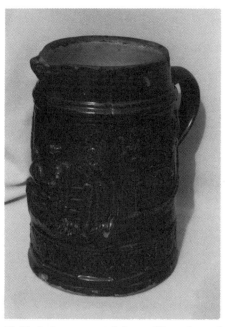

Molded stoneware pitcher with embossed decoration. $150-$175

Redware pitcher and milk pan from Pennsylvania, unmarked, mid-nineteenth century: pitcher, $100-$125; milk pan, $125-$140.

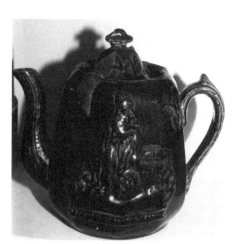

"Rebecca at the Well" molded pitcher, c. 1880. $200-$225

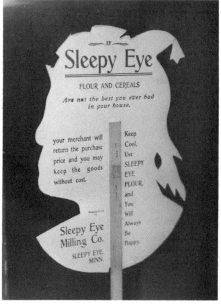

Sleepy Eye promotional fan. $200-$225

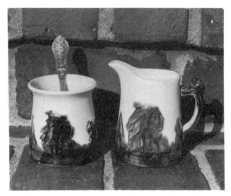

Sleepy Eye sugar and creamer. $400-$500

Sleepy Eye stein. $400-$500

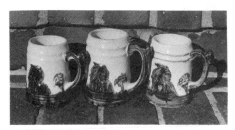

Sleepy Eye mugs. $200-$225 each

Sleepy Eye vase. $500-$575

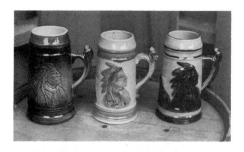

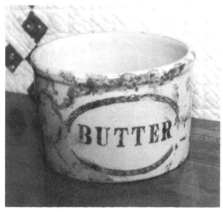

Molded spongeware butter crock. $200–$250

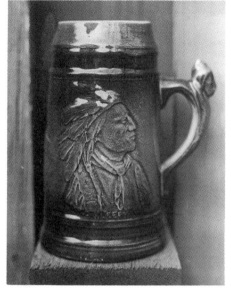

Sleepy Eye steins. $400–$600 each

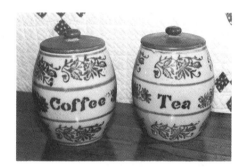

Molded stoneware rolling pins given as premiums, maple handles. $175–$210 each

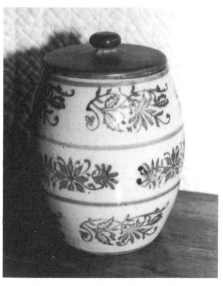

Transfer-decorated coffee and tea set molded. $150 set

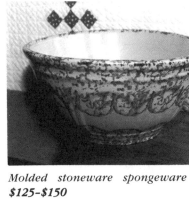

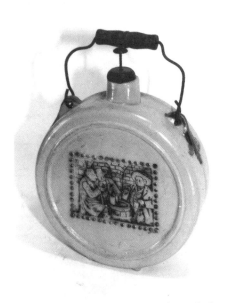

Molded stoneware spongeware bowl. $125-$150

Rare stoneware canteen, embossed decoration, from New York State. $200-$275

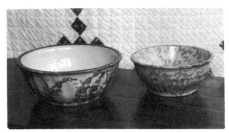

Spongeware bowls. $125-$150 each

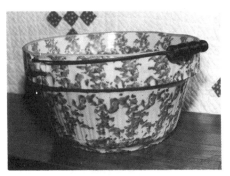

Molded spongeware mixing bowl. $125-$150

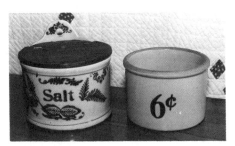

Stoneware salt crock with replaced wooden lid, $75-$125 "6¢" stoneware bowl, $75-$95.

Glossary

There are some basic terms that relate to collecting pottery that should be a part of every collector's working vocabulary.

Albany slip. Dark brown slip made from Hudson River clays and used most often to line the inside of stoneware jugs, churns, crocks, and jars. This slip also was used as an exterior slip on late nineteenth-century to early twentieth-century stoneware that was generally molded rather than thrown on a potter's wheel.

Bristol glaze. A nineteenth-century English glaze (white in color) used on molded stoneware in America during the 1880–1920 period.

China. Now almost a generic term for crockery tableware made from clays of varying quality, this term originally was used to describe high-quality porcelain tableware imported from the Orient in the Eighteenth and nineteenth centuries.

Craze. Cracks in the glaze of a piece of pottery.

Glaze. A shiny, glasslike coating that seals pottery to make it watertight, glaze also can bring out the natural color of the clay. Rock salt was used to add a glaze and "orange peel" appearance to the surface of stoneware. The salt was thrown into the kiln at the height of the firing process and quickly vaporized over the contents.

Greenware. Formed, dried, and ready-to-be fired pieces of pottery.

Hard Paste. A mixture of kaolin clay and petuntse (a clay with feldspar) fired at high temperature and used to make porcelain.

Porcelain. A high-quality hard-paste china comprised of kaolin clay and feldspar. Porcelain has been made in the Orient for almost 1500 years.

Redware. The first form of pottery produced in North America by firing clay at relatively low temperature 1400° F) and glazing with lead. The clay often was found at surface level. Redware pottery clays were porous and most of the pieces were glazed on the inside to keep the liquid contents from seeping through the clay.

Rockingham. A mottled, glazed surface that was popular on utilitarian pottery from the 1820s until 1900. Rockingham glaze was used on Toby jugs, pitchers, mixing bowls, cake pans, and other pieces. Some molded pieces came from Bennington, Vermont, and other much more

numerous, unmarked examples were produced in potteries in Illinois, Ohio, and Massachusetts.

Salt Glaze. Stoneware glaze made from salt and added to the kiln during the firing process.

Sgraffito. Decorations which were scratched or incised through the surface of slip-coated pottery. Sgraffito-decorated redware was more ornamental than functional.

Slipware. Redware pottery that has been decorated with a creamy substance made of clay called "slip," which was poured from a cup or applied with a simple tubelike utensil. Mo. American slipware was made in Pennsylvania Words, short phrases, or simple designs were added to the redware for decoration or presentation.

Soft Paste. Paste made from a combination of more common clays and fired at a lower temperature than hard paste. Soft paste requires that the glaze be watertight, and usually it is decorated because the clay combination easily absorbs the decoration.

Stoneware. Utilitarian pottery made from nonporous (watertight) clays fired at high temperatures (2300° F). The glaze is applied by adding rock salt to the kiln. American stoneware is primarily a product of the nineteenth century.

Yellowware. A form of molded utilitarian soft-bodied pottery covered with a clear or colorless glaze which enhanced the natural color of the clay.

Bibliography

If you are going to collect decorated stoneware, you need the five books listed below.

Greer, Georgeanna. *American Stonewares, The Art and Craft of Utilitarian Potters.* Atglen, Pennsylvania: Schiffer Publishing, 1981.

Guilland, Harold. *Early American Folk Pottery.* Radnor, Pennsylvania: Chilton Book Company, 1971.

Osgood, Cornelius. *The Jug and Related Stoneware of Bennington.* Rutland, Vermont: Charles E. Tuttle Company, 1971.

Ramsay, John. *American Potters and Pottery.* Boston, Massachusetts: Hale, Cushman and Flint, 1939. (This will probably be the most difficult of the five books to locate.)

Webster, Donald. *Decoratea Stoneware Pottery of North America.* Rutland, Vermont: Charles E. Tuttle Company, 1971.